IMAGES
of America

QUEEN CREEK

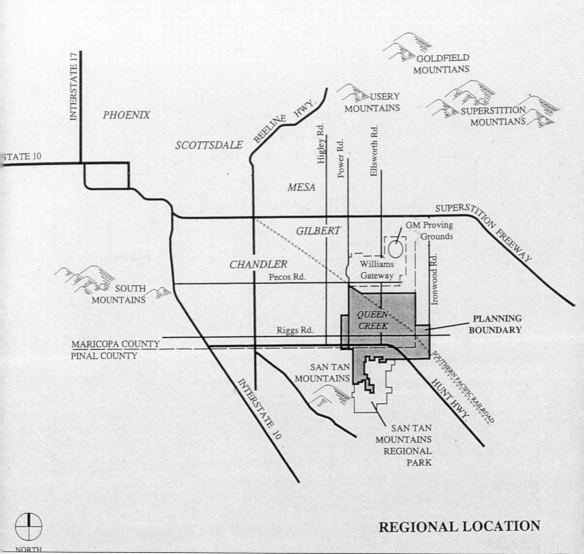

REGIONAL LOCATION

NORTH

Queen Creek is located 35 miles southeast of Phoenix. The town is on the southeastern boundary of Maricopa County, at the base of the San Tan Mountains. (Courtesy of the Town of Queen Creek.)

ON THE COVER: A visiting equestrian drill team waves to the crowd at the 16th annual Queen Creek Christmas parade in 1998. A local tradition even before the town's incorporation, the parade continues to this day. This photograph is from a collection taken by Queen Creek youth to document the history of the community. (Courtesy of the Town of Queen Creek.)

IMAGES
of America

QUEEN CREEK

Sylvia G. Acuña

ARCADIA
PUBLISHING

Published by Arcadia Publishing
Charleston, South Carolina

Printed in the United States of America

Library of Congress Control Number: 2013935431

For all general information, please contact Arcadia Publishing:
Telephone 843-853-2070
Fax 843-853-0044
E-mail sales@arcadiapublishing.com
For customer service and orders:
Toll-Free 1-888-313-2665

Visit us on the Internet at www.arcadiapublishing.com

To Carlos, Daniel, and Ruben.

CONTENTS

ACKNOWLEDGMENTS

Dave Salge presented me with the opportunity to work with Arcadia Publishing on a book about Queen Creek. He has acted as coach and mentor to me and has been supportive in every way. Dave scanned all photographs and transcribed my typewritten captions into a more modern format. He also graciously provided additional information on the San Tan Historical Society.

Alicia Santiago and Gloria Greer have been crucial in helping me navigate all the resources of the San Tan Historical Society. The society's volunteers have also been very supportive.

Carlos Acuña provided tech support at home and agreed to a simpler way of living these past several months.

I am very thankful to Sandy McGeorge, the management assistant for the Town of Queen Creek. Assisted by Marsha Hunt, they collected and shared many photographs of the early activities of a new town. They also shared photographs from the Youth Photography Project, which was funded by the Town of Queen Creek, the Arizona Commission on the Arts, and the National Endowment for the Arts. In the project, under the direction of Rebecca Ross and Jill Ownsby, Queen Creek youth focused on documenting the history of the community.

For research, I utilized Frances Brandon Pickett's book *Histories and Precious Memories of Queen Creek, Chandler Heights, Higley and Combs Areas, 1916–1960*, as well as the local histories written by Sue Sossaman. Back issues of *Chandler Heights Monthly* by editor Betty Nash provided background information. The Queen Creek Elementary School newsletter, the *Queen Creek Spudder*, written by Inez Wingfield's sixth-grade English class, gave information on school life in the 1960s.

I appreciate the assistance of the following people, who shared photographs and memories and provided information: Daniel Acuña, Tom Alberti, Shari Bewsey, Gordon Brown, Mary Camacho, Nina Camarena, Jeannie Carlson, Mary Clausen, Robert Clausen, Greg Combs, Jason Corman, Cathleen Gunderman, Griselda Gutierrez, Ron Hunkler, Jeri Kirkhuff, Shirley Lane, Ruby Morris, Betty Maddux, Thomas Murch, the Postal History Foundation, Alden Rosbrook, Chris Sossaman, Pastor Edward Stutz, Carole Whaley, Regina Whitman, and Cecilia Yañez.

Many of the images in this volume appear courtesy of the San Tan Historical Society (STHS) and the Town of Queen Creek (TOQC), including photographs from the Youth Photography Project.

INTRODUCTION

Does the town of Queen Creek have a Queen Creek? Yes, it does. North and east of the town are mountains and mining towns. Running downhill from one of those mines, the Silver Queen, was a creek named Picket Post Creek. When the mine was opened, the creek's name was changed to Queen Creek. The creek continues its journey through the mountains and the Queen Creek Canyon to the area now known as Queen Creek. Locally, it is called "the wash," or the Queen Creek wash. Longtime residents have memories of it actually having water in it, which it still does sometimes after unusually rainy seasons. The reservoirs to the north spill their water down the creek, where it travels far to get to the town. However, most of the time, Queen Creek is dry, instead showing the beauty of the desert throughout the seasons of the year. The wash has become a part of the town trails system so it can be enjoyed by all as a walking and equestrian trail. It also remains a habitat area for area wildlife.

Queen Creek has flourished as an agricultural and farming community, as the work started by the pioneer families was continued by new generations. Cattle, cotton, citrus, vegetables, dairies, grain fields, and the wonderful Pontiac potato were all a part of the landscape. The increasing population gave life to an active and busy elementary school, a 1925 schoolhouse that was embellished with the addition of barracks buildings that were made available after World War II. The barracks provided extra classrooms, a library, an auditorium, and a cafeteria. Children played on sports teams and celebrated holidays. They participated in spelling bees and traveled to the Phoenix Zoo. They had a school newspaper, a school nurse, and a cafeteria staff. No matter the occupation of their parents, all the children attended the same school. These children had the best backyard in the world. The *Mullin-Kille Queen Creek 1960 City Directory* recorded early businesses that gave a lift to the town: Western Cotton Products, Oscar's Market, Bi-Air Dust and Spray Service, Dory's Tavern, Wrights Queen Creek Market, Queen Creek Barber Shop, Fowler's Café, Ellsworth Welding Shop, and the Eastside Shell Service Station. The phone number of Elma's Café was YUKON 8-2700.

Just 35 miles to the northwest, things were changing quickly for the Phoenix metropolitan area. The March 1964 issue of *Arizona Highways* magazine reported that the population had increased from 100,000 in 1950 to 514,000 in 1964. Much of the growth was attributed to the good weather in the metropolitan area. Many people moved there for health reasons. After serving at nearby military bases and experiencing the good weather and the desert climate, many servicemen returned to make Arizona their home. The weather and the location also gave Phoenix the advantage in attracting the electronics industry. Automotive testing facilities were soon located in the Phoenix area. The General Motors Proving Grounds appeared north of Queen Creek. In the 1960s, cotton and cattle were still economic pillars in Maricopa County. But farming diminished in the following years, as more people went to work in the new factories.

Meanwhile, back in Queen Creek, Ernest Hawes began subdividing his farm into the Ranchos Jardines housing development in the early 1970s. The development was promoted as miniature farm lots, with one-to-three-acre irrigated homesites starting at $4,850 per acre. Buyers were encouraged to start orchards and bring their horses. Ranchos Jardines first brought the opportunity to live in the country while working in the city. Other developments would follow. In the 1980s, there was increased building activity in Queen Creek. The nonprofit group Citizens for Queen Creek obtained a Community Development Block Grant to build the community center. The building would house a fire department and a branch of the county library. In 1982, school board officials broke ground on a new elementary school for grades one through eight. This led to further expansion of the school district to include the upper grades.

Long-standing traditions for the people of Queen Creek include the annual Fourth of July celebration and the annual Christmas parade. The Fourth of July celebration dates back to the 1940s, with the Schnepf family. In the 1950s, the celebration became a tradition for the Queen Creek Ward of the Church of Jesus Christ of Latter-day Saints. The community was invited to a picnic supper, fireworks, baseball, and watermelon. By the 1980s, the Kiwanis Club was sponsoring the celebration as a community service to Queen Creek. Mary Clausen credits Irene Crewse with starting the Christmas parade tradition. Initially, the parade was started for children, but it has grown greatly through the years, always reflecting the growth of the community. The 30th annual parade took place in 2012.

On July 25, 1989, the 84th municipality of Arizona was born when Queen Creek residents voted to incorporate. The area of the new town was 11 square miles, with a population of approximately 2,600. In the August 20, 1989, issue of *Chandler Heights Monthly*, editor Betty Nash reported, "The Citizens of Queen Creek for Incorporation Committee wish to thank you for the MANDATE at the polls. You set a record for largest percentage voting of those authorized to vote (55%). You set a record in the percentage of those (68%) voting in favor of a unified town, and you clearly stated you want to have a voice in your future. You have proved again, that people are not in a city, they are the city."

The Kiwanis Club was chartered in 1985, beginning an era of local nonprofit groups. Volunteerism became an important part of the Queen Creek community. The Friends of the Queen Creek Library organized to raise funds and support library programs. The San Tan Historical Society saved the 1925 brick schoolhouse to renovate it into a museum for the community. Mary Gloria started her own nonprofit organization to help those in need, and her charitable Pan de Vida Foundation continues to this day. The Greater Queen Creek Horse Owners Association safeguarded the equestrian lifestyle, Desert Cry advocated for the desert wildlife, and San Tan Mountain PRIDE kept watch over the foothills.

In 1997, the *Arizona Republic* newspaper reported that, from 1990 to 1995, Maricopa County had lost 55 square miles of farmland. In Queen Creek, there was five percent less farmland in 1995 than there had been in 1990. Investors owned half of the town's farmland, encroaching urban life was making it difficult to farm, and residents complained about noise, dust, and animals. By 2000, with a population approaching 4,000, the town had settled into its rural lifestyle. There are still no traffic lights, but the new century is bringing unprecedented growth and many new challenges for the town and its people.

One

LEADERSHIP

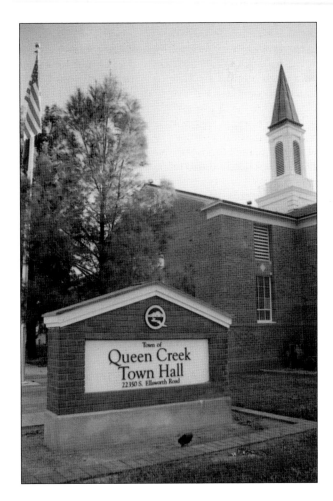

Opened for town business since 1992, the Queen Creek Town Hall has proven to be a building for the people. It is used as a venue for club and committee meetings, educational classes, youth and library programs, and family celebrations. Town clerk Claudia Diffenbaugh became Claudia DiBiasi in the first wedding held at the town hall, in October 1992. (TOQC.)

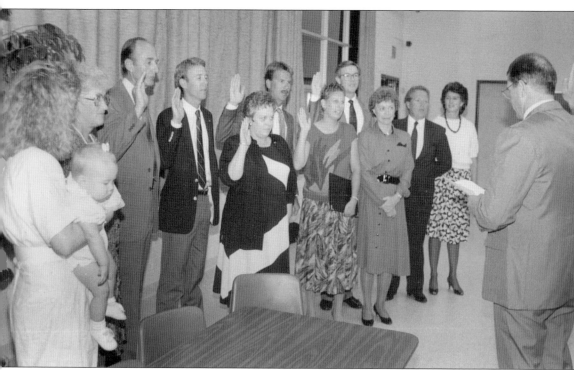

Tom Freestone (far right) of the Maricopa County Board of Supervisors administers the oath of office to the first Queen Creek Town Council on September 20, 1989. The ceremony took place at the Queen Creek High School cafeteria. Town citizens voted to incorporate by a two-to-one margin, and, on July 25, 1989, Queen Creek became the 84th municipality in Arizona. Seen with their hands raised are, from left to right, Thomas Murch, Stephen Sossaman, Sally Davis, Paul Gardner, June Calendar, Mark Schnepf, and John Wertin (in dark suit, hand obscured). The seven-member charter council served until the next election, the following year. The council elected Mark Schnepf as mayor. The town budget was the first order of business. The population was 2,000 at the time, and 24 citizens applied for council positions. Tom Freestone chose the seven-member council for their diverse backgrounds. The appointments were confirmed by the board of supervisors on September 5, 1989. (STHS.)

The first elected town council was sworn in on June 6, 1990, at the Queen Creek Community Center. On July 1, services from Maricopa County ceased, although the new town contracted with the county for police and animal control. The town's 1990–1991 budget was $1.4 million, including $150,000 to purchase a former church for use as town offices. (STHS.)

Tom Freestone (below, far right) addresses the audience at the 1990 swearing-in ceremony. Sitting from left to right are town attorney William E. Farrell, council members Paul Gardner and Sharon Coleman, and mayor Mark Schnepf. Not shown are council members Sally Davis, David Johnston, Thomas Murch, and vice mayor Stephen Sossaman. Carol Glasgow served as town clerk. (TOQC.)

```
                    TOWN OF QUEEN CREEK
                 SWEARING-IN CEREMONIES
             WEDNESDAY, JUNE 6, 1990, 7:00 P.M.
                QUEEN CREEK COMMUNITY CENTER

CALL TO ORDER:                       Mayor Mark Schnepf

PRESENTATION OF FLAG                 Boy Scout Troop 82,
  AND PLEDGE OF ALLEGIANCE:          San Tan District

INVOCATION:                          Reverend Morris Ohlin,
                                     Grace Fellowship
                                     Assembly of God Church

WELCOME:                             Mayor Schnepf

PRESENTATION TO OUTGOING             Mayor Schnepf
COUNCIL MEMBERS

REMARKS                              June Ann Calender
                                     John L. Wertin

REMARKS                              Tom Freestone,
                                     Supervisor, District 1,
                                     Maricopa County

SWEARING-IN OF NEWLY ELECTED
COUNCIL

DRAWING OF LOTS BY TOWN              Carol Glasgow, Town
COUNCIL FOR STAGGERED TERMS          Clerk and  William E.
                                     Farrell, Town Attorney

ELECTION OF MAYOR BY TOWN COUNCIL

SWEARING-IN OF MAYOR                 Supervisor Freestone

ANNOUNCEMENT OF VICE MAYOR           Newly Elected Mayor

SWEARING-IN OF VICE MAYOR            Senator James Sossaman,
                                     Arizona State Senator,
                                     District 30

REMARKS                              Senator Sossaman

REMARKS FROM COUNCIL MEMBERS         Sharon R. Coleman
                                     Sally M. Davis
                                     Paul T. Gardner
                                     David W. Johnston
                                     Stephen J. Sossaman

CLOSING REMARKS                      Mayor Schnepf

RETIREMENT OF COLORS                 Troop 82
```

Tom in Hawaii

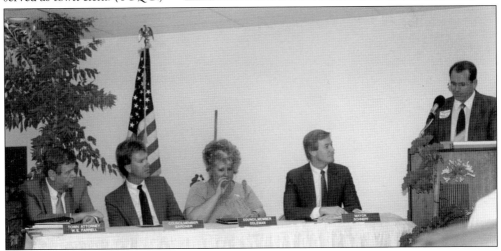

11

Mark Schnepf became Queen Creek's first directly elected mayor at the 1992 swearing-in ceremony held at town hall. Here, from left to right, are Mayor Schnepf, state senator James Sossaman, and Stephen Sossaman, who had been serving as the interim mayor. Antonia "Toni" Valenzuela and Thomas Rye were sworn in as the newest council members. Following the ceremony, tours were given of the recently renovated north wing of town hall. (TOQC.)

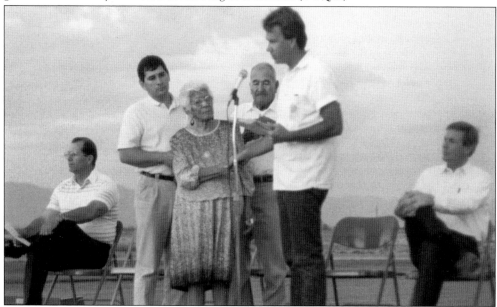

Council member Paul Gardner presents Rosenda Aldecoa and her family with a plaque at the May 1990 dedication of the Waldo Aldecoa Sr. Ball Field at Founder's Park. Seated on the left is Tom Freestone of the county board of supervisors. Mayor Mark Schnepf is seated on the right. Waldo Aldecoa Sr. died in 1987, leaving a legacy of generosity and hard work to his family and friends. (STHS.)

Thomas Murch, a retired lieutenant colonel in the Air Force, moved to Queen Creek in 1985. He was involved in the incorporation efforts and served for eight years on the town council, starting with the charter council. He also served two years as vice mayor. Murch was inducted into the 2003 class of the Arizona Veterans Hall of Fame. (STHS.)

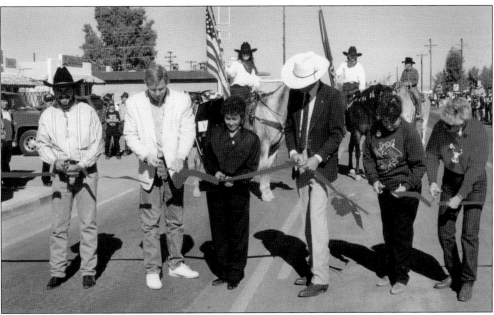

The mayor and the council start off the 11th annual Queen Creek Christmas parade with a ribbon cutting on Ellsworth Road. From left to right are Thomas Rye, Mayor Schnepf, Antonia Valenzuela, Thomas Murch, Sally Davis, and June Calendar. The parade showcased the people and businesses of the community. (TOQC.)

Above, town council members attend the first annual community tree lighting in December 1993 at town hall. From left to right, they are Thomas Murch, Mayor Schnepf, June Calendar, Thomas Rye, and David Johnston. Jo Anne Rye was appointed chairman of the tree-lighting project by the town council. She organized a two-hour program of local musical groups. Participating in the inaugural event were Jeri Jones, the Amazing Grace Singers, the First Ward of the Church of Jesus Christ of Latter-day Saints choir, Grace Community Church choir, and Bryan Becker on the keyboard. Cookies, punch, and cocoa were served. Children enjoyed having their pictures taken with Santa. (Above, STHS; below, TOQC.)

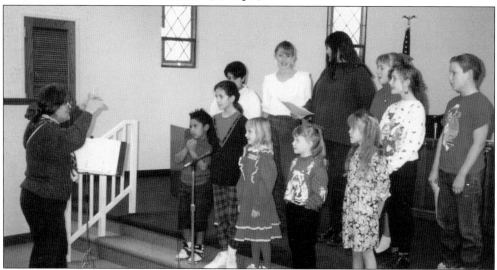

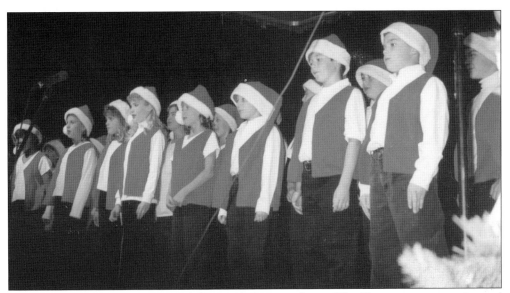

Since 1993, the town has continued the tree-lighting tradition. The Christmas tree was donated by Schnepf Farms in 1992, and it always stands in front of town hall. An important part of the ceremony has been musical entertainment by local youth. Participants have included the Queen Creek Elementary School choir (above), the Queen Creek High School band, the Arizona Boys Ranch Ambassador choir, the Parks and Recreation gymnastics class, and the Queen Creek Elementary Las Aguilas Folklorico Dancers. After the entertainment, the community gathered outside for the tree lighting. Afterwards, refreshments were served inside by the Friends of the Queen Creek Library. Children, including the young Folklorico dancer below, visited with Santa and were photographed with him. (Both, TOQC.)

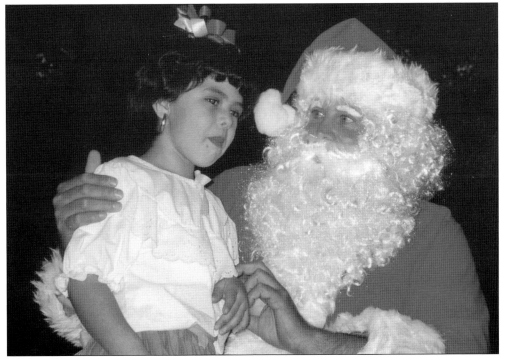

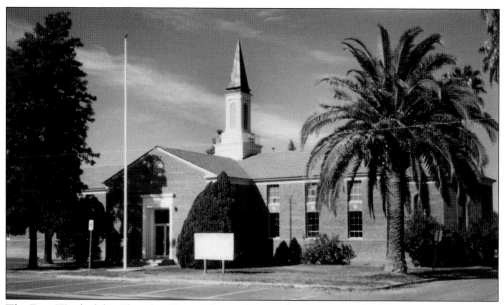

The First Ward of the Church of Jesus Christ of Latter-day Saints was built by the community on land donated by Leo Ellsworth. The church was dedicated on June 8, 1952. A new church was built in 1989 to accommodate growth. The newly incorporated Town of Queen Creek purchased the former church building and the accompanying nine acres for $325,000 to use as the new town hall. This photograph is dated September 16, 1993. (STHS.)

After the Phase I remodel that was completed in 1992, the Phase II remodel work started in February 1993. The chapel area was remodeled into council chambers. The recreation hall and stage were renovated and made available for community use. The estimated cost of the renovations was $65,000. In 1993, about 3,000 people called Queen Creek home. (STHS.)

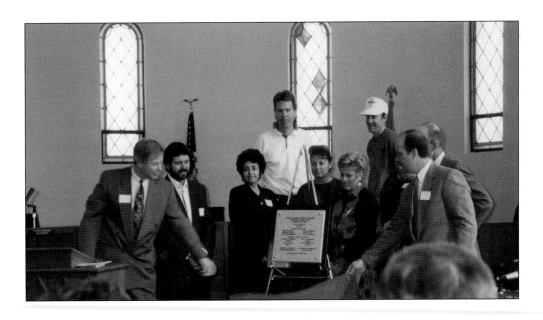

Above, the mayor and the council unveil the dedication marker. From left to right are mayor Mark Schnepf, Thomas Rye, Antonia Valenzuela, former council member Paul Gardner, Joyce Hildebrandt, June Calendar, former council member Stephen Sossaman, vice mayor Thomas Murch, and David Johnston. Murch spoke about the history of the building. Self-guided tours of the new council chambers and the new town multipurpose room and stage followed the ceremony. The town had also improved the ball field behind the building. Town clerk Claudia Diffenbaugh and town administrator Michael J. McNulty are still the town's two employees. (Both, STHS.)

You are cordially invited to attend the dedication ceremony

of the Queen Creek Town Hall on

Saturday, January 22, 1994 at 10: 00 a.m. in the morning.

22350 South Ellsworth Road

Queen Creek, Arizona

Time passes quickly when you are building a new town. Here, council members (from left to right) Joyce Hildebrandt, Antonia Valenzuela, and June Calendar celebrate Queen Creek's sixth year as a town on September 6, 1995, with a birthday cake. The town received an award from the Arizona Planning Association in 1991 for Best Comprehensive and General Plan. (TOQC.)

These unidentified youngsters sit outside town hall and enjoy a hot dog supper following the burial of the Town of Queen Creek's 10th anniversary time capsule. Youth were invited to pick up a shovel and help seal the site. These children will be over 50 years old when the capsule is opened in 2049. (TOQC.)

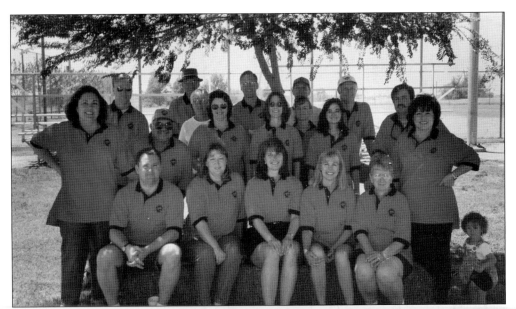

The Queen Creek town staff gathers in the ball field near town hall for their annual picnic in 1998. Cynthia Seelhammer, the first full-time town manager, is standing on the far left in the second row. Town clerk Sandra McGeorge is seated second from right in the first row. Betty Nash, the editor of the *Chandler Heights Monthly*, wrote of them, "The staff take their positions and their involvement in the community seriously." (TOQC.)

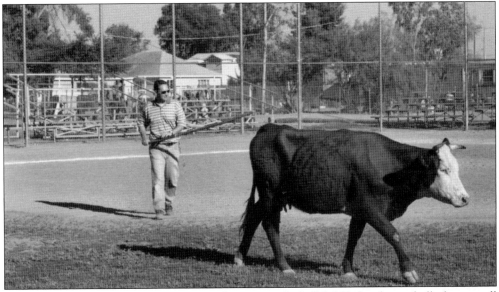

Scot Rigby, a management assistant, wrangles cows in the ball field behind town hall after a small herd escaped from a nearby pasture. This was not in Rigby's job description, but he may have brought it up at his next performance review. Citizens often came face-to-face with a wandering cow, goat, horse, or chicken. (TOQC.)

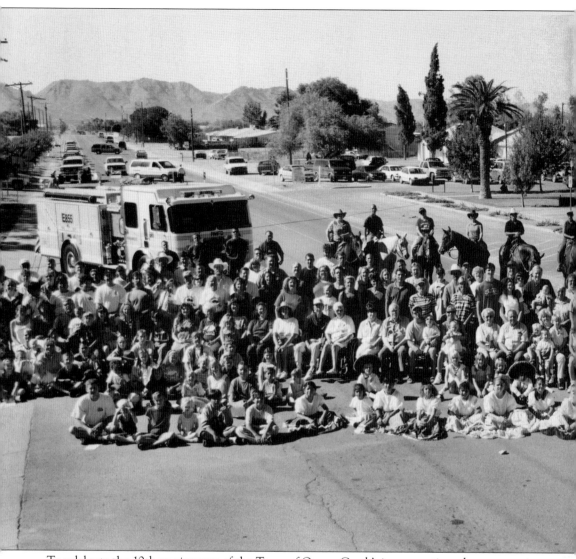

To celebrate the 10th anniversary of the Town of Queen Creek's incorporation, the community was invited to sit for a town photograph. The town population was approximately 4,000 at the time. Neighbors, families, schoolchildren, volunteers, town staff, firemen, policemen, and

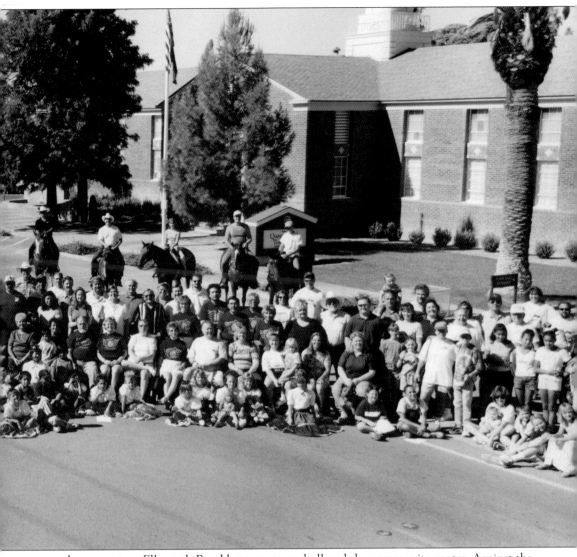

even horses met on Ellsworth Road between town hall and the community center. Against the backdrop of the San Tan Mountains, the many faces of the Queen Creek community smiled for the camera. (TOQC.)

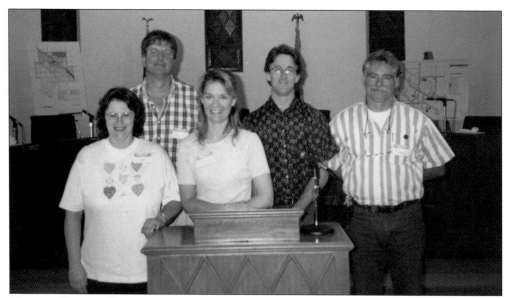

These graduates of the Citizen Leadership Institute were recognized at a council meeting in 1998. Citizens attended the institute, a series of sessions teaching the basics of town government and the issues facing Queen Creek. The institute prepares citizens to participate in leadership roles within the community. The program received the 1997 Arizona Governor's Award for Excellence in Rural Development. (TOQC.)

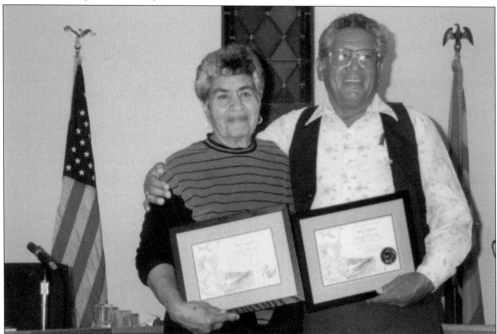

Volunteers make a community strong. Recognizing this, the Town of Queen Creek initiated the Outstanding Volunteer of the Year Award. Here, Mary and Milo Camacho accept the 1998 Volunteer of the Year award during a council meeting. The couple has been active in the Kiwanis Club and at Our Lady of Guadalupe Catholic Church. Mary is famous in the community for her delicious tamales. (TOQC.)

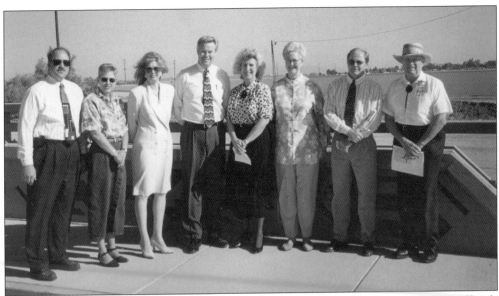

Mayor Mark Schnepf (fourth from left), town council members, and Maricopa County officials gather for the 1996 dedication of the South Ellsworth Bridge at Queen Creek. The town council and Queen Creek citizens worked closely with the Maricopa County Department of Transportation to participate in the design of the bridge. (TOQC.)

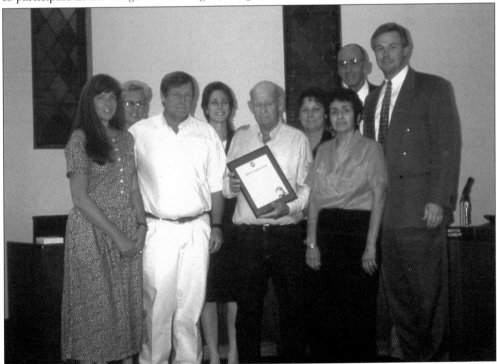

The Combs family was recognized by the Town of Queen Creek for their many years of community service. Seen here from left to right in the first row are Diane Combs, Greg Combs, and Bill Combs. Bill was a pioneer farmer in the Queen Creek area. The family has supported the Thunderbird 4-H Club and the Future Farmers of America program for decades. (TOQC.)

The first Queen Creek Youth Center opened in July 1998. Purchased with a community development building grant, the prefabricated building was situated on a five-acre parcel south of the community center on Ellsworth Road. With a strong parks and recreation program directed by Debra Gomez, the center was a welcome resource. As seen here inside the building, Queen Creek youth enjoyed games, music, and homework help during after-school hours. (TOQC.)

A delegation from the town of Jesus Maria in Aguascalientes, Mexico, visited Queen Creek in 1998 to begin the process of establishing a sister city relationship for cultural and educational exchange. From left to right in the first row are Aguascalientes mayor Josè Luis Mares Medina, Mrs. Medina, Queen Creek mayor Mark Schnepf, and his wife, Carrie Schnepf. The Mexican delegation was interested in the youth center and recreational programs. (STHS.)

Every summer, the Queen Creek Parks and Recreation Department sponsored youth baseball and softball leagues. Registration for the program began in the spring. Children attended a free clinic to learn more about the sport. Teams were sponsored by local businesses and community groups. Games were held in the evenings and on Saturday mornings. The season ended with the Youth Summer Ball Awards. Past sponsors have included Rudy's Restaurant, the Kiwanis Club, Schnepf Farms, Barney Farms, Alliance Lumber, the Rural Metro Fire Department, and Queen Creek Primary Care. (Both, TOQC.)

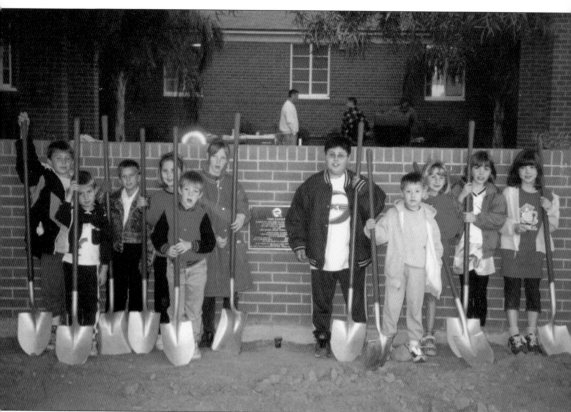

Town of Queen Creek Resolution 214-99, dated December 1, 1999, declared the 10th anniversary time capsule a public record to be opened by the town council serving in July 2049. With the help of these 11 youngsters, the time capsule was buried outside town hall. Items selected by town residents and staff are contained in the capsule, which was engineered by TRW Vehicle Safety Systems. It was dedicated at the 10th anniversary celebration in September 1999. Chuck Lopez created a logo for the special event with the slogan "Small Town Tradition, Great Town Ambition." Items in the capsule include the town's general plan, a community profile, newsletters, the capital improvement plan, the town budget, and points of pride. Popular culture items include Pokemon battle figures, Beanie Babies, a Ricky Martin CD, a Giga Pet keychain, and a *Rugrats* water toy. Written histories of Higley, Combs, and Queen Creek are also included. (TOQC.)

Two

TRADITION

Captured by Queen Creek youth Colleen Martin, these two unidentified Folklorico dancers participated in the 1998 annual Christmas parade with Las Aguilas Folklorico Dancers. Martin participated in a photography project to document the history of the community through its youth. (TOQC.)

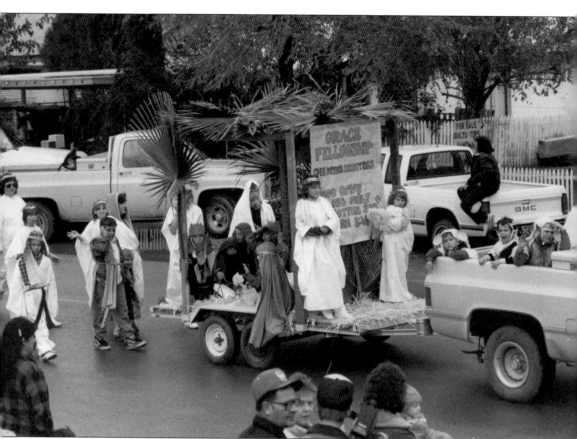

The Children's Ministry of Grace Fellowship Assembly of God participate in the 1987 Christmas parade, reenacting the Nativity scene with much detail. It appears the sheep have abandoned the fields for the back of a pickup truck. A sign tacked onto a tree in the right background announces, "For Sale: Quilts and Tops, Handmade." There were no sidewalks at the time. Grace Fellowship was on Ellsworth Road south of town hall. The historic building was a former Ellsworth family farmhouse. The church was opened in 1986 by Rev. Morris Ohlin and his wife, Patricia. They served the community for 12 years before leaving in 1998 for Colorado to work with teenagers. Town manager Cynthia Seelhammer described the Ohlins as good neighbors who supported the community. The church building was demolished in 2012. (STHS.)

The judges for the third annual Christmas parade, in 1987, were (above, from left to right) Irene Simpens, Betty Nash, and Frank Snelling. All lived in the Chandler Heights area, and Nash was the editor of the *Chandler Heights Monthly*. The judges are seated in front of the Queen Creek Water Company. The parade, sponsored by the Kiwanis Club, started at the Queen Creek School and proceeded south on Ellsworth Road to the community center. Parade entry categories included floats, animals, horse groups, 4-H groups, trucks, farm vehicles, and the much appreciated "pooper scoopers" (below). (Both, STHS.)

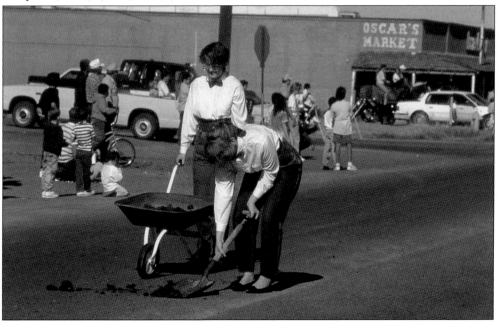

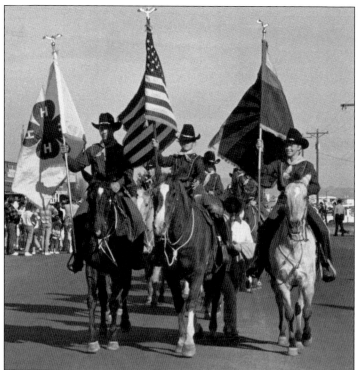

The Thunderbird 4-H Color Guard opens the 1988 Christmas parade walking south on Ellsworth Road. The large, active horse group met at Combs School and at Jim Hiner Arena in the Country Mini Farms development. Longtime resident and business owner Mary Clausen credits Helen Hiner with starting the 4-H horse group in the Queen Creek area. (STHS.)

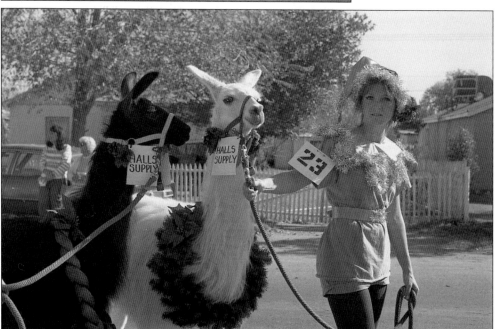

Entry number 23 in the 1988 parade was Hall's Supply, represented by Kelly Pidgeon and her two male llama companions, Bo and Bart. The boys so enjoyed the walk down Ellsworth Road that they took time to visit with parade onlookers, holding up the whole parade. Hall's Supply, located at 18433 South Rittenhouse Road, was owned by Don and Barbara Peacock. The business sold fittings, hoses, and valves. (STHS.)

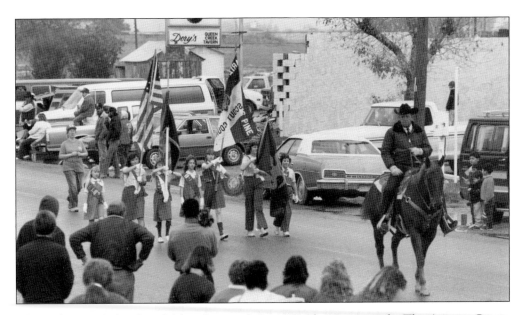

The Girl Scout Color Guard (above) opened the 1987 Christmas parade. The Arizona Cactus Pine Scout Council has been in Phoenix since 1936. The council keeps flags and uniforms from different historical periods for troops participating as a color guard. Dory's Queen Creek Tavern was Queen Creek's oldest business. In the 1930s, Leo Ellsworth sold the building, on the southeast corner of Ocotillo and Ellsworth Roads, to Earl and Lottie Dory. The tavern was operated continually by the same family until 1986. It opened under new management in 1987. Seen below is Brownie Troop 1425, from the San Tan neighborhood, in 1988. *Chandler Heights Monthly* regularly reported on the activities of Girl Scout Troops 434 and 1740, Brownie Troop 1352, and Junior Girl Scout Troop 980. (Both, STHS.)

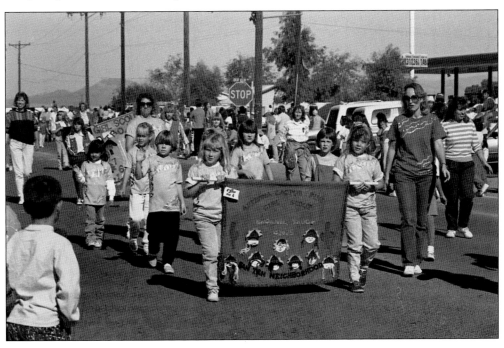

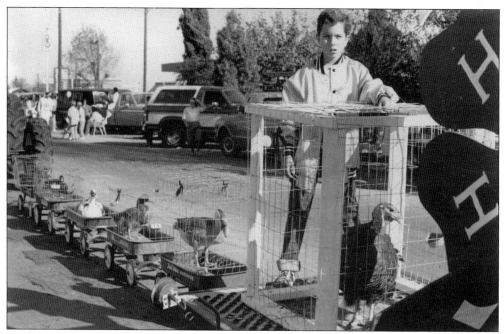

These two 1988 4-H parade entries exemplify the meaning of the Queen Creek Christmas parade. The parade was initially created with youth in mind. The 4-H participants enjoy the opportunity to share their projects with the community. The photograph above shows the face of an intent young man who has carefully planned the best way to show a turkey and a goose while still keeping all his ducks in a row. The cages have been crafted using wagons, each decorated with its own Christmas bow. Below, a grateful and obedient turkey decked out for the holidays admires the crowd from atop a hay bale. The Queen Creek Thunderbird 4-H Club was the largest group in Pinal County and included youth from Maricopa County as well. They competed in the Pinal County Fair every spring. (Both, STHS.)

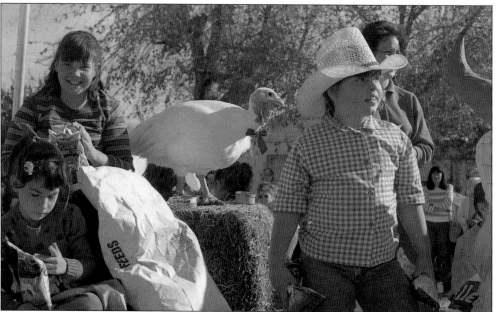

Queen Creek pioneer farmer Jasper Sossaman is seen here at the 1987 Christmas parade. He helped bring an irrigation system to the area and founded the Queen Creek Potato Growers Association. Betty Binner Nash was the editor of *Chandler Heights Monthly*, a local publication she started at the age of 14. (STHS.)

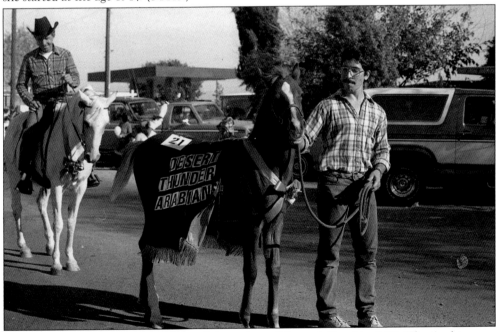

Paul Dunn leads a colt named Desert Falcon down Ellsworth Road in 1988. The Arabian was later nicknamed Studley for his strong attraction to the mares. During an outing in 1995, he bolted into the desert of the San Tan Mountains and never returned. He was later seen on the Gila River Reservation accompanied by several mares. Desert Thunder Arabians was started in 1982 by Jeri and Carl Jones. (STHS.)

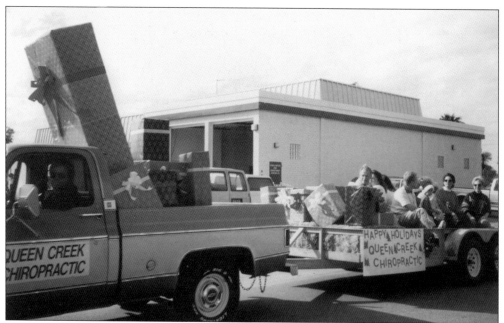

Dr. William Gunderman and the staff at Queen Creek Chiropractic were frequent participants in the annual Christmas parade. They received plaques for two first-place wins and one second-place win. The staff eventually waved the white flag to office manager Cathleen Gunderman, exhausted by the consecutive years of float building. (Queen Creek Chiropractic.)

Members of the 1998 Queen Creek High School Bulldogs football team proudly display their Metro Conference Championship Final Four trophy. After three consecutive losing seasons, the Bulldogs and coach Duane Madsen rallied and ended the season with 10 wins and 3 losses. The Bulldogs lost to undefeated Thatcher in the state 2A final playoff game by a score of 28-12. (TOQC.)

The Queen Creek community watched the parade from different places, as seen in these two photographs from 1990. Above, atop the Queen Creek Water Company building on Ellsworth Road, are the parade announcer and other onlookers. Paul Gardner was the president of the water company, continuing the work of his grandfather Taylor Gardner, who acquired the water company from Leo Ellsworth in 1972. Many horses participated in the parade, with some of them providing seating for spectators, as seen below. This group is watching from the northwest corner of Ellsworth and Ocotillo Roads as Tom Agnos, the Maricopa County sheriff, passes in the parade. (Both, STHS.)

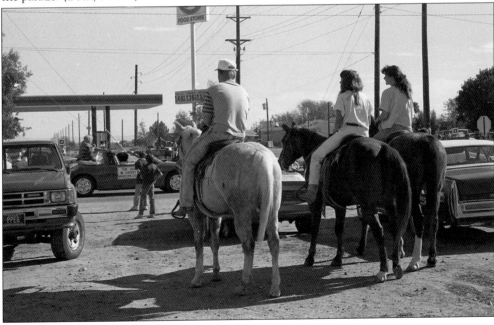

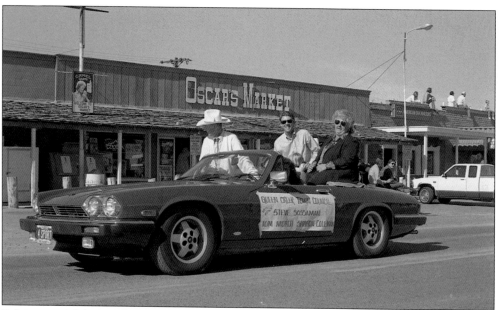

Politics entered the parade in 1990 with the first elected town council. From left to right are Thomas Murch, Stephen Sossaman, and Sharon Coleman. Oscar's Market, owned by Oscar Figueroa, opened in the late 1950s. Figueroa's son James took over the business in 1970. It then changed owners through the years. The building still stands today, although it is now vacant. (STHS.)

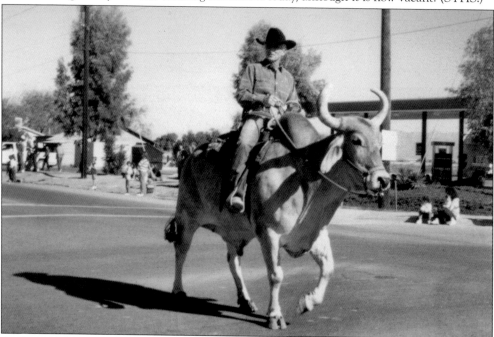

As the grand marshal of the 1993 Christmas parade, prominent automobile dealer Tex Earnhardt rode his Brahma, named Queen Creek, down Ellsworth Road. With the staging area on Rittenhouse Road, the sounds of passing trains startled the waiting horses, but the Brahma remained calm. Past grand marshals include former Arizona State University football coach Frank Kush and newscasters Kent Dana and Sean McLaughlin. (TOQC.)

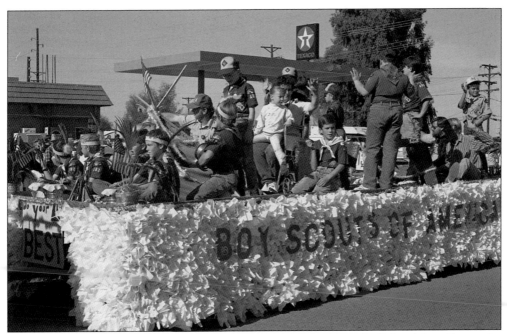

Above, Boy Scout Troop 182 participates in the 1990 Christmas parade. Behind their float is the Texaco gas station that was on the southwest corner of Ellsworth and Ocotillo Roads, in front of Jim's Restaurant. Below, Boy Scout Troop 287, sponsored by Our Lady of Guadalupe Catholic Church, prepared lunch at the community center after the parade. In the June 1990 issue of *Chandler Heights Monthly*, editor Betty Nash reported, "A very successful bake and rummage sale was held at the church with proceeds going to Boy Scout Troop 287 for camping equipment. The Scouts and their Scout Masters, Frank Miller and Charlie Catlin, try to have a campout each month." (Both, STHS.)

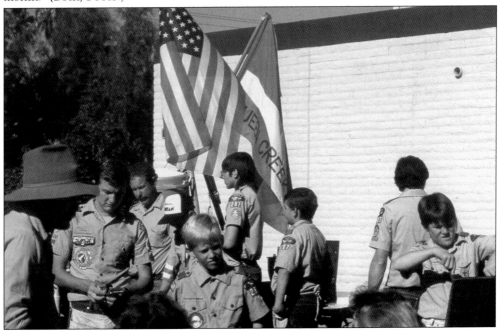

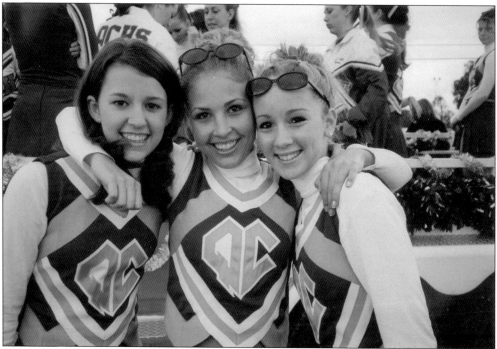

The Town of Queen Creek sponsored Queen Creek Through the Eyes of its Youth, a photography project that encouraged youth to explore photography. Jill Ownsby, a ninth-grade English teacher at Queen Creek High School, was selected to teach the photography class. Her group's photographs of the Christmas parade were exhibited at the town hall. The photograph above, taken by Sheila Trevizo, is entitled "Bulldog Cheerleaders." In the original caption, Trevizo wrote, "Queen Creek High School Cheerleaders (left to right) Jocelyn Strebeck, Jonna Leone and Brittany Sanderson show their spirit of pride in both their school and their town." The photograph below, taken by Daniel Duarte, is entitled "The Scouts." Duarte wrote, "These young scouts take one split second away from the Christmas parade to gaze into the camera lens and show the entire town that they have Christmas cheer." (Both, TOQC.)

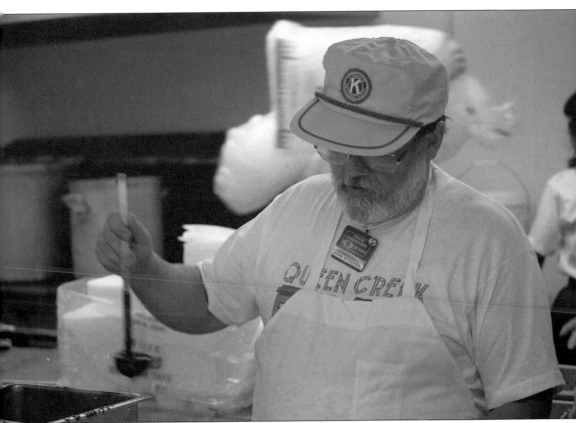

John Stocker, a Kiwanis club member, works in the kitchen of the community center, serving barbeque dinners to residents at the 1990 Queen Creek Fourth of July celebration. An architect, Stocker opened his business, the Architects Studio, in 1985. He designed the 1993 town hall remodel of the Latter-day Saints church. The Queen Creek Kiwanis organization was chartered in 1985. The focus of the international service group is to help children and youth. Through fundraising efforts, the club raises money for scholarships and supports the summer baseball league. They have also sponsored the annual Christmas parade, and the annual Fourth of July celebration is always sponsored by Kiwanis as a service to the community. Kiwanis business meetings are remembered fondly by members, who recall that the meetings included a catered dinner prepared by Mary and Milo Camacho. For $5, members enjoyed a home-cooked meal before the meeting. (STHS.)

The June 20, 1987, issue of *Chandler Heights Monthly* announces the upcoming Fourth of July celebration in Queen Creek. A town tradition since the 1940s, when Raymond Schnepf first hosted a barbeque and fireworks display for family and friends on his farm, the celebration has continued to grow through the years. By the 1950s, the Queen Creek Ward of the Latter-day Saints Church was sponsoring the annual celebration. The community was invited to bring a picnic

NTHLY VOL. 3 NO. 4 JUNE 20, 1987

POSTAL PATRON LOCAL
If undeliverable Do Not Return

Bulk Rate
U.S. POSTAGE PAID
Higley , Az 85236
Permit No. 14

REEK POST OFFICES
R HEIGHTS, AZ, 85227
; 2 IN $21.75; 5 IN. $63.75 **PH. 988 - 2528**
42 - $5.00 A YEAR. CIRCULATION 3200 PLUS

CAR-RT.-SORT

h **CELEBRATION**

MORE FIREWORKS THAN LAST YEAR

JLY

Celebration Ever !!

Q.C. COMMUNITY CENTER

— GAMES — RAFFLE

LIVE COUNTRY MUSIC

FROM 9 PM to 12 PM

$5.00 ADULTS
$3.00 CHILDREN 12 & UNDER

supper and enjoy the fireworks at the church ball field. Newell Barney donated watermelon for everyone. After the fireworks, the championship softball game of the Queen Creek League was held. Businesses, churches, and families sponsored their own teams. By the 1980s, the Kiwanis Organization was sponsoring the event at the Queen Creek Community Center. (STHS.)

41

This photograph looks east at the Queen Creek Community Center from Ellsworth Road in 1990. No fencing had been installed yet, and there was no sidewalk. The Fourth of July barbeque dinner was served at 5:00 p.m. and cost $5. Fireworks began at dusk. The evening concluded with a softball game at Aldecoa Park. (STHS.)

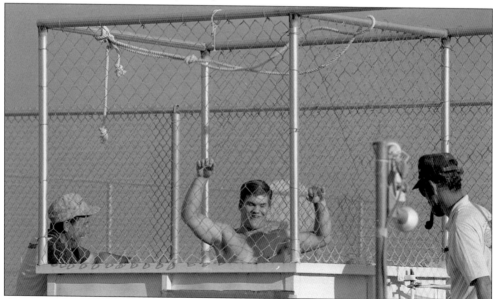

A victim of the dunk tank sinks into the cold water at the 1990 Fourth of July celebration. Games and other activities also supported fundraising efforts. As Queen Creek was a small community a distance away from the larger neighboring towns, the Fourth of July event was unique in providing residents the opportunity to celebrate the holiday close to home. (STHS.)

Three

INITIATIVE

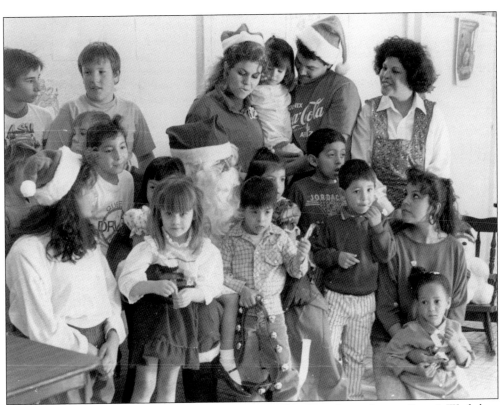

Cecilia Yañez (standing, far right) transforms the wooden Army barracks into Santa's Workshop at this annual event at Our Lady of Guadalupe Mission Church, seen here in 1987. Elves assist the children in choosing and wrapping a gift for their parents. Visits with Santa, portrayed by Charlie Austin, followed. When Los Arcos Mall in Scottsdale closed, Yañez was able to obtain the larger, padded Santa chair used at the mall. (STHS.)

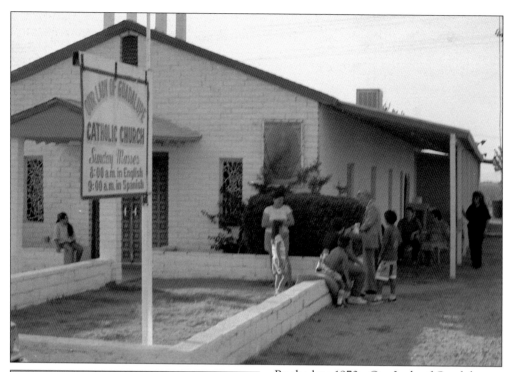

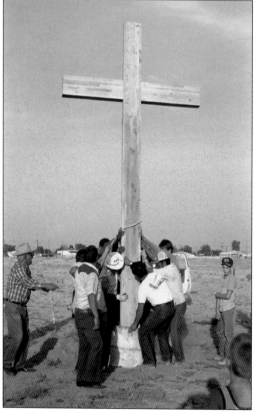

By the late 1970s, Our Lady of Guadalupe Catholic Church, seen above on Ocotillo Road, could not accommodate all of its parishioners. Many people had to stand outside and watch the mass through the windows. During the Arizona summer, this was very uncomfortable. In 1987, Father Douglas Lorig announced that planning would begin for a new church. Bernadette Heath was appointed building coordinator. With donated funds, services, and labor, the new building became a reality. Land was acquired across the street for the new church in 1988, and, on June 15, 1988, the cross at left was placed on the property by parishioners. The new church was dedicated in December 1989. (Both, STHS.)

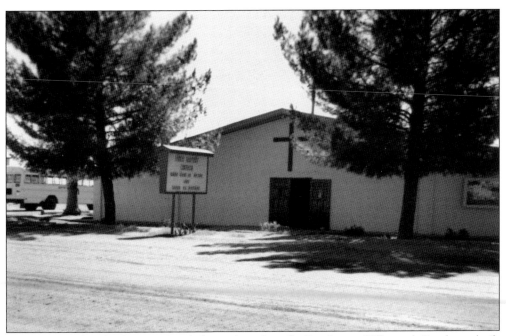

First Baptist Church of Queen Creek, located on Ocotillo Road east of Ellsworth Road, was built in 1946 through a community effort. In the 1980s, the church served the migrant farm worker population and had an active migrant ministry. Edward Stutz currently serves as the pastor of the church, which was renamed Family of Faith Fellowship. The original church bell is still stored on the premises. (STHS.)

Harvest Temple Church of God was located at 20536 West Ocotillo Road. The building no longer stands. When this photograph was taken in 1995, the church was approximately 45 years old. The most recent pastor, Alicia Casares, was known for her annual children's Christmas program, which provided gifts and Christmas dinner to low-income families. The generosity of the Queen Creek community supported her endeavors to help families in need. (STHS.)

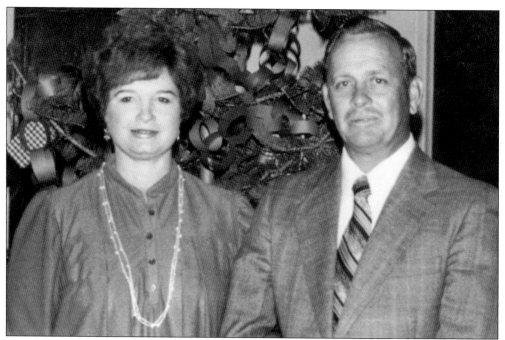

Gloria and Phillip Greer participated in the Christmas program at the cultural hall of the Church of Jesus Christ of Latter-day Saints. Phillip was appointed bishop of the Queen Creek Ward in 1979 and served until 1984. His counselors were Gary Cummard and Alyn McClure. The Queen Creek Ward was dedicated in 1952. John Freestone was the first bishop. (Gloria Greer.)

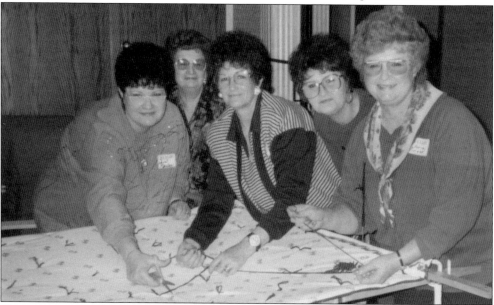

The annual quilting bee takes place at the Queen Creek Ward of the Church of Jesus Christ of Latter-day Saints. These quilters are, from left to right, Pam Marlar, Iola Bix, Linda Bentley, Connie Davis, and Gloria Greer. During the bee, 15 quilts are completed in one day by a group of 40 women. The quilts are donated to hospitals, nursing homes, and other charitable organizations. (Gloria Greer.)

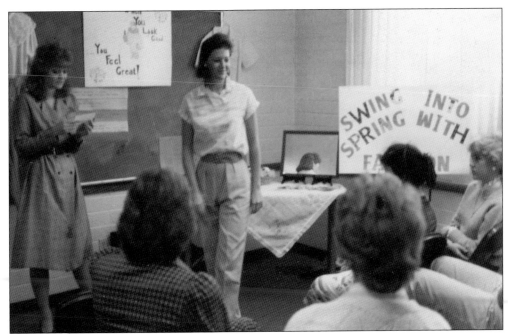

Swing into Spring with Fashion was a regular event organized by the young women of the Queen Creek Ward of the Church of Jesus Christ of Latter-day Saints. Here, Kathy Greer (far left) moderates the fashion show in one of the church's classrooms. The young women modeled outfits of their own design. (Gloria Greer.)

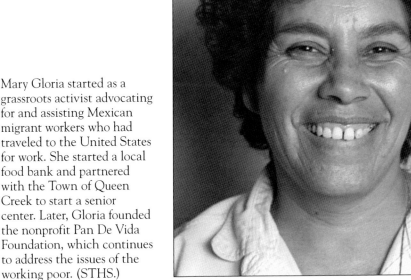

Mary Gloria started as a grassroots activist advocating for and assisting Mexican migrant workers who had traveled to the United States for work. She started a local food bank and partnered with the Town of Queen Creek to start a senior center. Later, Gloria founded the nonprofit Pan De Vida Foundation, which continues to address the issues of the working poor. (STHS.)

On September 19, 1996, the first meeting of the Friends of the Queen Creek Library was called to order. The charter officers were Hal Carrington, Dora Kisto, Linda Peterson, and Sandie Brown. The all-volunteer group raises funds through popular used book sales that benefit library programming and remains active today. (Friends of the Queen Creek Library.)

Louise White (left) and Carol Whaley, charter members of the Friends of the Queen Creek Library, prepare for a used book sale in the library courtyard after the annual Christmas parade. Their used book sales were a popular event in the community, with children's books selling quickly. Proceeds benefited programs for children and adults at the library. (Friends of the Queen Creek Library.)

Joy Messer (left) was the branch manager of the Queen Creek Library for 15 years, from 1989 to 2004. She was also an avid quilter who shared her passion with the community by donating her finished work for annual raffles that raised funds for library programs. Here, she presents Queen Creek High School teacher Jona Henry with the quilt she won. (Friends of the Queen Creek Library.)

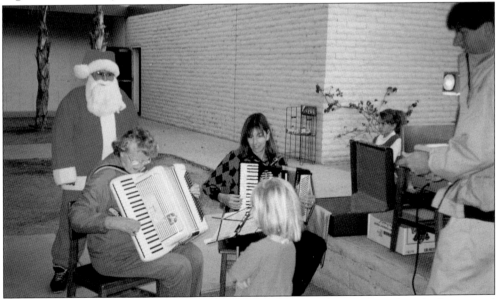

Accordionists Marian Cadman (left) and Pam Schweitzer play Christmas carols at the first annual Holiday Fireside, sponsored by the Friends of the Library. The event, held at the community center in December 1997, was started by member Paul Schweitzer (standing, right), who wanted to create a family event closer to home. The tradition continued until 2003. (Sylvia Acuña.)

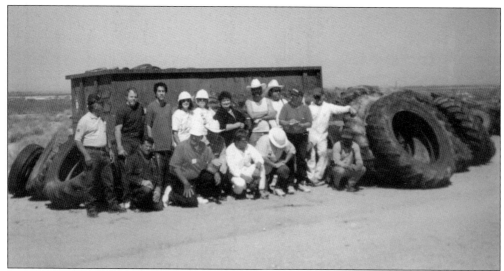

San Tan Mountain PRIDE organized the first community cleanup in 1999 as a joint effort with Pinal County, Maricopa County, the Town of Queen Creek, and area residents. In all, 12 miles of the Queen Creek planning area benefited. Here, members of PRIDE and the Pinal County staff stand in front of a dumpster provided by PolyTek Recycling Company for car and truck tire collections. (STHS.)

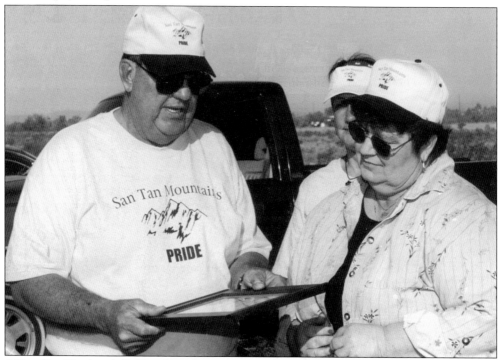

Alden "Ros" Rosbrook (left) and Sandie Smith, the Pinal County supervisor, coordinated the San Tan Mountain PRIDE community cleanups. Rosbrook organized PRIDE in 1997 in response to illegal activity and the illegal dumping of garbage in his desert community. The cleanups became annual events. In the largest cleanup, 900 tons of garbage was collected over a 31-mile area by 450 volunteers. (TOQC.)

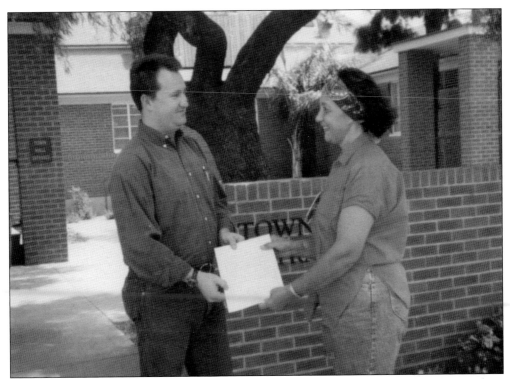

Joe LaFortune of the Town of Queen Creek accepts signed petitions in favor of annexation from Regina Whitman, a wildlife rehabilitator and a member of Citizens for the San Tan Regional Park. The Queen Creek Town Council voted to annex over 2,000 acres in the San Tan Mountain foothills to prevent the Box Canyon housing development. (Regina Whitman.)

An unidentified member of the Greater Queen Creek Horse Owners Association prepares for a group activity. The volunteer group was incorporated in 1996 to support and educate horse owners. The association also maintained a presence at town hall to keep informed of equestrian issues. The group also donated and installed a hitching post at town hall, which was dedicated in June 1996. (TOQC.)

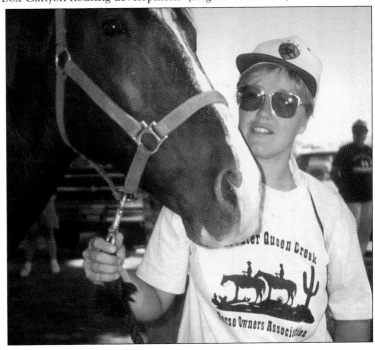

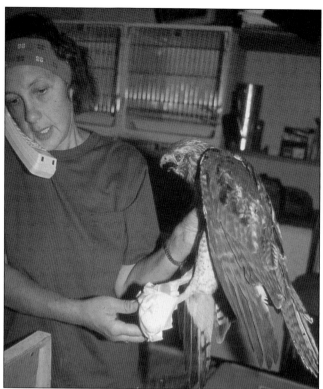

Regina Whitman moved from New York to the Queen Creek area in 1993. She settled on three acres in the San Tan Mountain foothills to open her nonprofit animal sanctuary, Desert Cry. As a wildlife rehabilitator, Whitman is licensed to care for injured and abandoned animals until they can be released back into the wild. (Regina Whitman.)

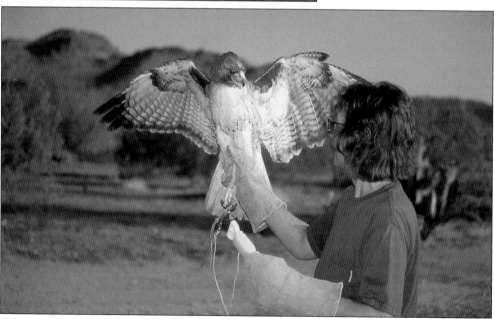

Whitman's work included caring for injured birds of prey. In 1996, she attended a meeting of the Pinal County Board of Supervisors with an injured hawk perched on her hand to protest the Johnson Ranch housing development, near the San Tan Mountains. Encroaching development continues to threaten the habitat of wildlife. For a time, Whitman wrote a regular column for the *Chandler Heights Monthly*. She currently rehabilitates small mammals only. (Regina Whitman.)

In 1999, more than 100 people participated in the one-mile hike of the Miner's Claim Trail for the inaugural Walk in the Park event at San Tan Mountain Regional Park. Hikers received plastic bags to collect garbage on the trail. The five people who collected the most garbage received caps and shirts from Desert Cry animal sanctuary. (STHS.)

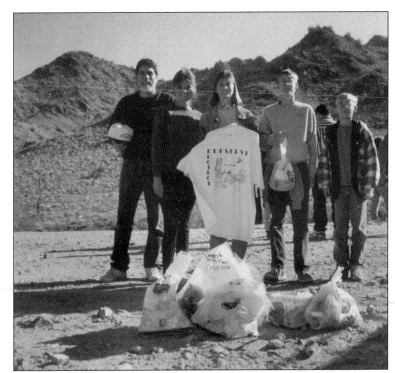

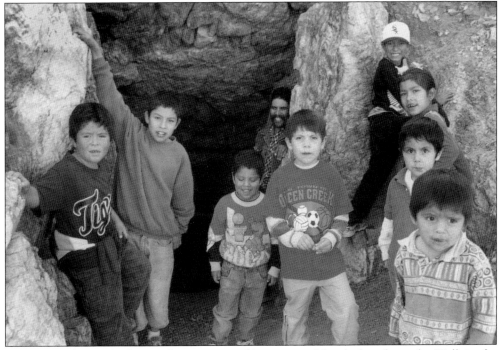

Jose Salazar (center background) accompanied his sons and family friends on the Walk in the Park hike to Miner's Cave in the San Tan Mountains. Local residents described the cave as a tunnel and mine shaft that was popular with young people as a meeting place. Many names were scratched on the walls. The cave was sealed in the 1990s. (STHS.)

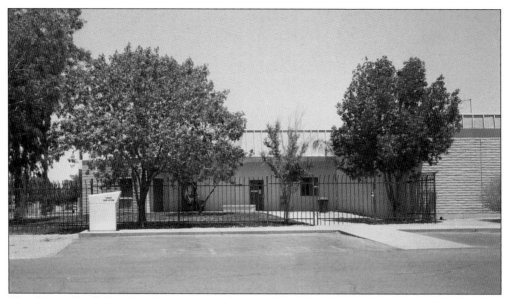

The Queen Creek Community Center was built in 1983 on Ellsworth Road. The nonprofit group Citizens for Queen Creek received a Community Development Block Grant from Maricopa County for the project. The main tenants of the building were the Rural Metro Fire Department and the Maricopa County Library. In 1996, the title to the building was transferred to the Town of Queen Creek. (STHS.)

The Queen Creek branch of the Maricopa County Library occupied a 1,200-square-foot space at the Queen Creek Community Center. The two-person library staff offered a monthly book discussion group for adults, and children participated in the annual summer reading program. Four computer stations were available. The Friends of the Queen Creek Library supported programming and purchased the first computer for the library. (Sylvia Acuña.)

54

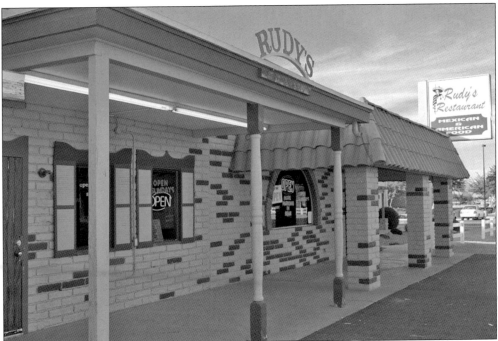

Rudy's Restaurant, the landmark Queen Creek restaurant, has been open since 1975 at 21224 Ellsworth Road. Owners Antonia "Toni" and Rudy Valenzuela serve American and Mexican meals with free ice cream cones for dessert. A native of Queen Creek, Antonia has served on the town council, while Rudy was named Volunteer of the Year in 1996. They have been strong supporters of local sports teams and town events. (STHS.)

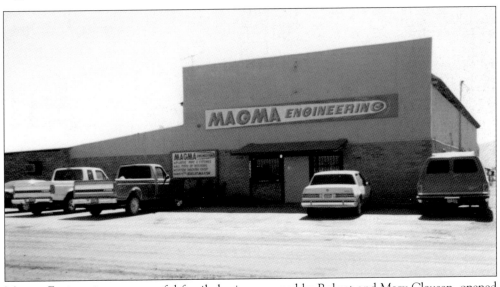

Magma Engineering, a successful family business owned by Robert and Mary Clausen, opened in 1970. The company offers automatic bullet casting, machine work, and welding, and serves customers all over the world. It is located at 20955 East Ocotillo Road in a former barn that was home to Hildebrandt Brothers Service Garage in the 1960s. Mary Clausen was chairman of the annual Christmas parade for 12 years. (STHS.)

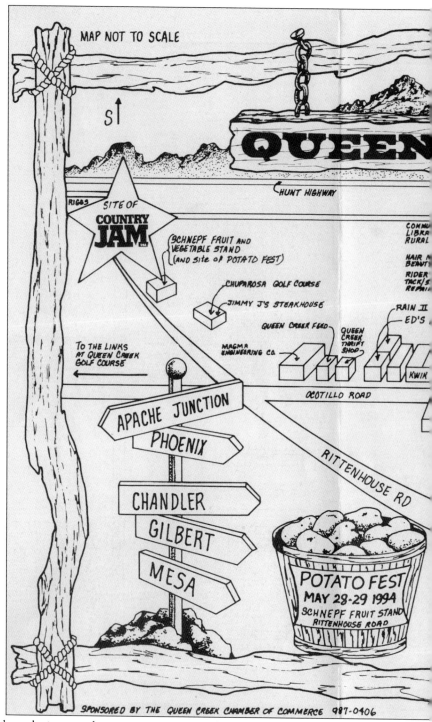

The spring of 1994 brought increased economic activity to the Town of Queen Creek. With a population of approximately 3,000, the five-year-old town celebrated two large events: the first Country Jam USA music festival, and the third annual Potato Fest. Both events took place at Schnepf Farms. This detailed map sponsored by the Queen Creek Chamber of Commerce and

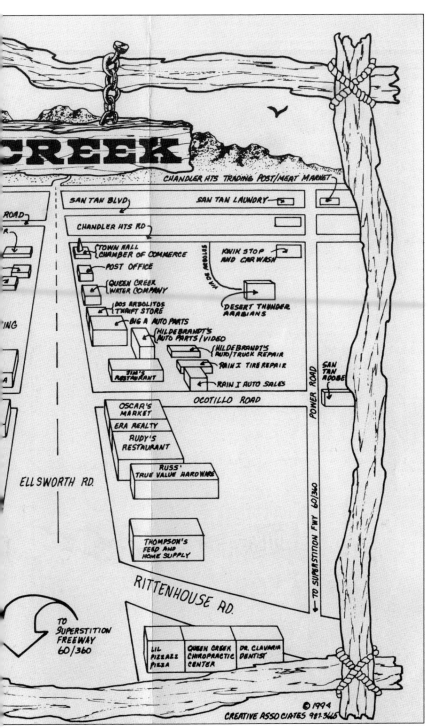

designed by Creative Associates shows the town center area and the businesses at the main intersection of Ocotillo and Ellsworth Roads. Rittenhouse Road follows the railroad line from the Maricopa and Pinal County line to Williams Field Road. (STHS.)

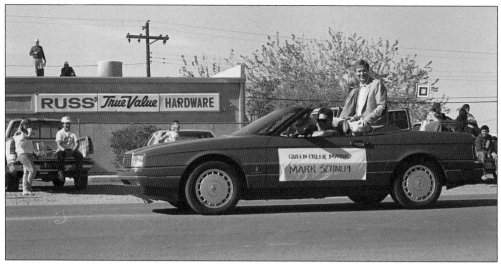

The first elected town council chose Mark Schnepf to serve as mayor in 1990. Behind him in this parade photograph is Russ's True Value Hardware, which first opened in 1974 on the southwestern side of Ocotillo and Ellsworth Roads. In the early 1980s, owners Russ and Jeannie Carlson built a new store north of the original location, at 21820 South Ellsworth Road. The popular business continues today in its new location at 20231 East Ocotillo Road. (STHS.)

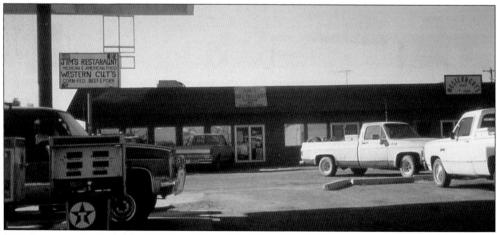

Jim's Restaurant opened in 1987 on the southwest corner of Ellsworth and Ocotillo Roads. The building was a former Tastee Freez, which explained the drive-through window on the east side. When the adjacent Texaco gas station was removed, the parking area was enlarged. Space was rented to Western Cuts butcher shop. Jim and Sara Sanchez closed the restaurant in 2000. (TOQC.)

Jason Corman has been working at the Pork Shop with his father-in-law Greg Combs since 1994. The *Arizona Republic* has called Corman the "face of the Pork Shop." He has been featured in several news articles for his skills in butchering and customer service. Alfonso Tzintzun (not shown) has worked for the Combs family for over 40 years, both on the farm and in the store. (Greg Combs.)

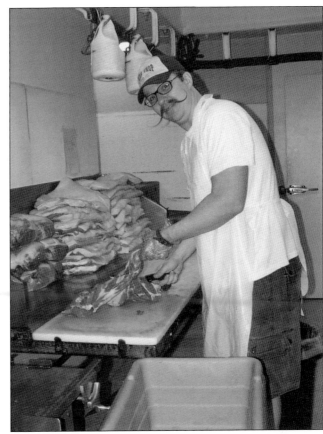

Greg Combs (below) opened the Pork Shop in 1979 on the corner of Combs and Schnepf Roads. Growing up on a farm that was involved in 4-H and Future Farmers of America projects, Combs's continued interest in swine led him to open his own meat store. In its 1997 Best of Phoenix Awards, *Phoenix New Times Magazine* selected the Pork Shop as the Best Place to Buy Pork. (Greg Combs.)

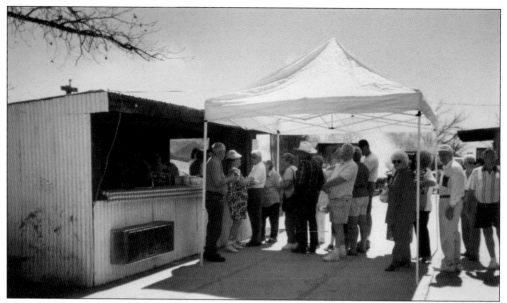

The Pork Shop is famous for its bratwurst sausage. Every year, the annual brat fry attracts hundreds of people from Pinal and Maricopa Counties. Customers line up at the Brat Barn to purchase a fresh bratwurst on a bun for $1. Music and picnic tables complement the event. (Greg Combs.)

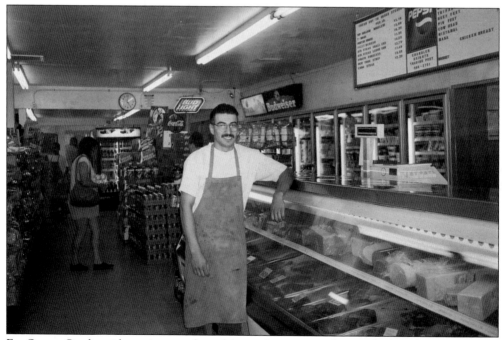

For Queen Creek residents, it was a short drive to the meat market inside the Chandler Heights Trading Post. The store has been located on the southwest corner of Power Road and San Tan Boulevard since 1946. Employee Leo Velasquez, seen here, was always ready to help customers behind the meat counter. In 1999, boneless top sirloin cost $3.19 per pound, while one entire cow head was valued at $24. (TOQC.)

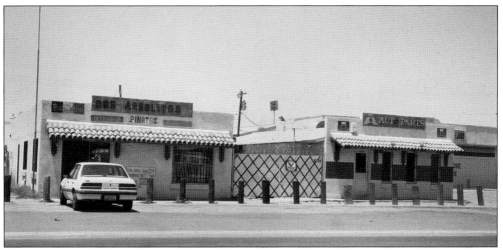

Dos Arbolitos Imports, at 22030 South Ellsworth Road in the center of town, offers a variety of Mexican products for sale. Customers can choose items from candy, tortillas, and sweet bread to blankets, boots, and sombreros. Owners Francisco and Griselda Gutierrez are proud of their large selection of piñatas. The couple opened the store in March 1989. The building, built in the 1960s, was originally the Queen Creek post office. (TOQC.)

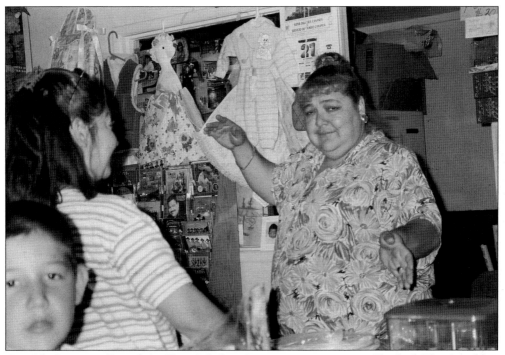

Griselda Gutierrez (far right) of Dos Arbolitos Imports greets customer Elizabeth Ureña and her son Caesar. The store is open every day, providing a place for customers to meet and talk. Beside Gutierrez, small clothing items and popular Mexican music recordings are for sale. In July 2000, Griselda traveled to Jesus Maria, Aguascalientes, Mexico, as part of the Queen Creek Sister City Commission representing local business. (TOQC.)

Above, the staff at Queen Creek Chiropractic, located at 20740 South Ellsworth Road, poses for a photograph. The staff includes, from left to right, (first row) Griselda Sandoval, Ophelia Herrera, and Dr. William Gunderman; (second row) Dolly Brady and Travis Brady. Dr. Gunderman has been bringing relief to Queen Creek residents since 1993. He wrote a regular column for *Chandler Heights Monthly* and began a fibromyalgia support group for patients. When a patient from Michigan expressed her desire to get the feel for Arizona living, the staff decided to greet her in full Western attire for her next visit. Seen below in full Arizona dress are, from left to right, Dr. Gunderman, Cathleen Gunderman, and Kyra Whipp. (Both, Queen Creek Chiropractic.)

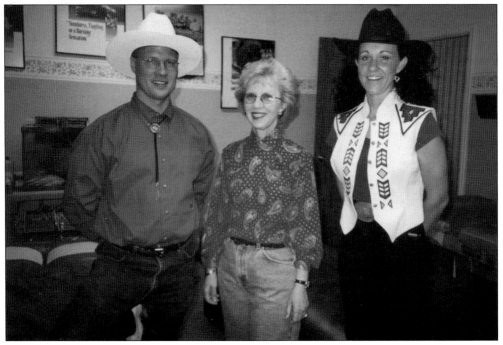

The Schnepf family has been farming in Queen Creek since 1941. The Peach Festival tradition began after the family added a new orchard of peaches and apricots. The first Peach Festival was held in 1993. Every May, weather permitting, people come to the farm for fresh peaches. (TOQC.)

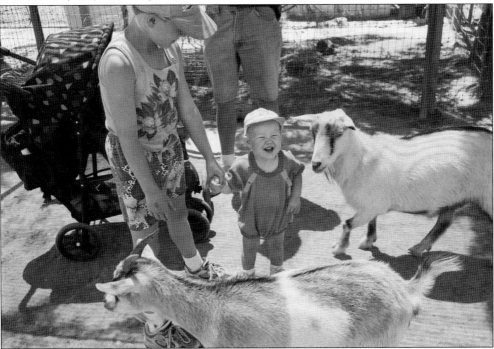

A young child expresses his glee at being in the presence of friendly goats at the Schnepf Farms petting corral. This photograph was taken by Colleen Martin in 1999 as part of a youth photography project sponsored by the Town of Queen Creek and the Arizona Commission on the Arts. (TOQC.)

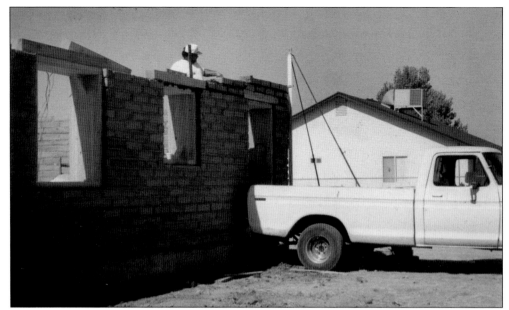

John Morris of San Tan Adobe lays down adobe block for a residence in the Ranchos Jardines neighborhood. Morris has been working with adobe for over 40 years. He opened his business in Queen Creek in 1983 and was the main supplier of adobe brick in the Phoenix area. He built his own adobe home, as well as other residences in Queen Creek. (Sylvia Acuña.)

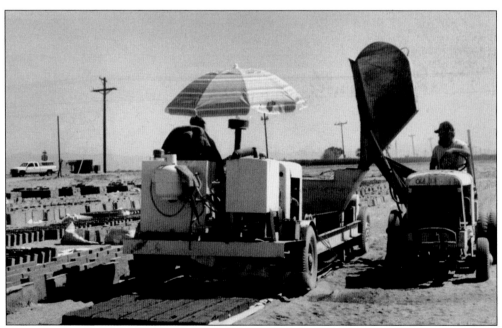

Here, the mud buggy's hopper delivers fully stabilized mud into the hopper of the lay-down machine. The machine then stamps the mixture into adobe blocks, producing 30 to 40 blocks at a time. The blocks dry and cure in seven to eight hours. Up to 3,500 blocks can be produced in a day with a crew of four. The adobe yard was located on Sossaman Farms. (Sylvia Acuña.)

Four

HERITAGE

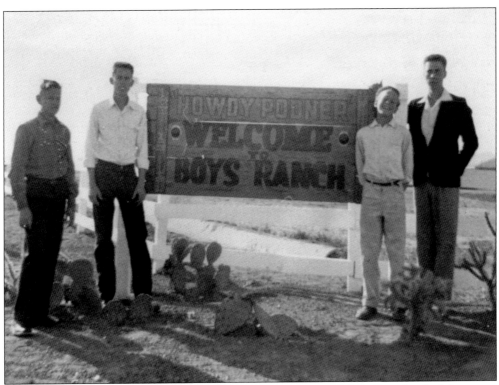

Four unidentified youths stand by the entrance sign to the Arizona Boys Ranch, which became a nonprofit organization in 1949. The ranch's three founders, George Miller, Howard Pyle, and Al Waters, were members of the Phoenix Rotary Club. Miller was a Boy Scout executive, Pyle was a Phoenix radio announcer and a former war correspondent who became the governor of Arizona in 1951, and Waters was a Phoenix businessman. (STHS.)

Rev. Wendell Newell (left) and Esther Newell attend to business in this 1950s photograph. Reverend Newell served as the superintendent of the Arizona Boys Ranch for 15 years and then as its executive director. He pursued service clubs for financial support, which resulted in the construction of four additional cottages built from 1955 to 1960. The American Legion, Phoenix Sky Harbor Kiwanis, Encanto Kiwanis, and the Arizona State Elks Club all sponsored cottages. (STHS.)

Funds to build the first cottage at the ranch came from the Burridge Butler Foundation. Butler had once been the principle stockholder in Phoenix radio station KOY. The Butler Cottage was dedicated in September 1951. The first boy to come to the Arizona Boys Ranch was 12-year-old Eddie Contreras of Phoenix. (STHS.)

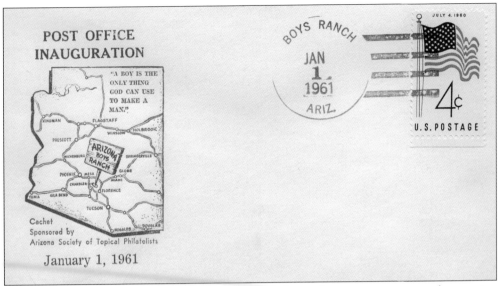

POST OFFICE
INAUGURATION

"A BOY IS THE
ONLY THING
GOD CAN USE
TO MAKE A
MAN."

Cachet
Sponsored by
Arizona Society of Topical Philatelists

January 1, 1961

The Arizona Society of Topical Philatelists sponsored a cachet to commemorate the opening of the Arizona Boys Ranch post office. The 50-star American Flag commemorative stamp seen here was first issued on July 4, 1960. The 50th star represented the new state of Hawaii, which was admitted to the Union on August 21, 1959. The Boys Ranch community also appeared on the 1965 Arizona highway map. (STHS.)

The Arizona Boys Ranch acquired its own post office in January 1961. The ranch's new address was Arizona Boys Ranch, Boys Ranch, Arizona, 85224. The previous address had been Rural Route 1, Box 17-A, Queen Creek. The administration was elated because the new address recognized the Boys Ranch as a community and not an institution. (Photograph by Robert Bechtel; courtesy of the Postal History Foundation.)

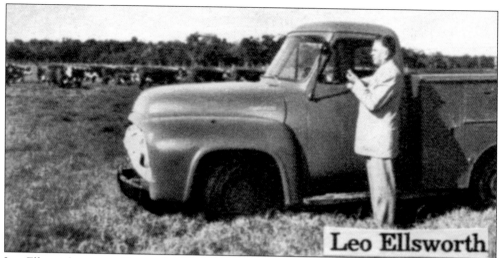

Leo Ellsworth came to Queen Creek in 1927 when he purchased the Rittenhouse farm from the bank. He was later joined by his brothers Larence and Donald in a partnership to operate a farm, general store, and gas station. The brothers raised cotton, produce, sheep, cattle, and a dairy herd. Leo brought the first telephone line to the area. (STHS.)

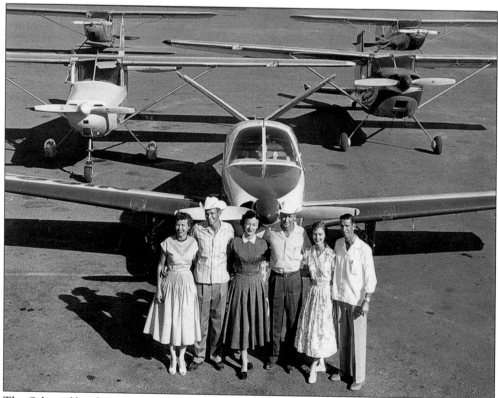

The Schnepf brothers and their wives stand by their five family-owned aircraft in 1955. They are, from left to right, Maude and Jack Schnepf, Thora and Raymond Schnepf, and Carolyn and Max Schnepf. The brothers were farmers in the Queen Creek area. The families were members of the Arizona Chapter of the Flying Farmers Association. (STHS.)

Queen Creek farmers Gene Hall (left) and Bill Brandon proclaim their membership in the Maricopa County Farm Bureau. In 1955, the bureau had over 2,000 members. The bureau was an independent association of farmers who worked with the Arizona legislature to discuss issues related to agriculture, livestock, and flood control. (STHS.)

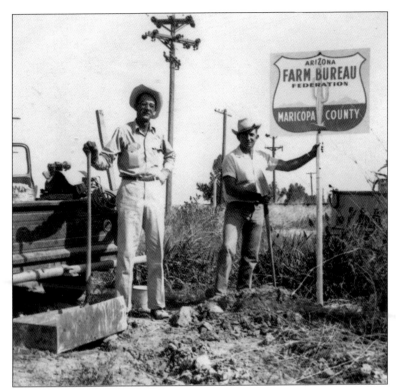

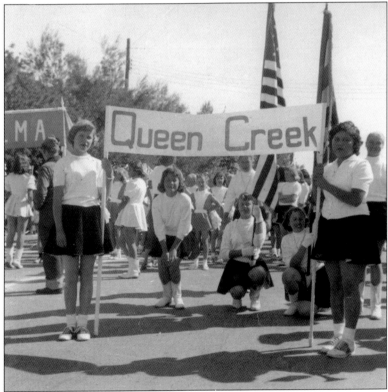

Found in the archives of the San Tan Historical Society, this 1950s-era photograph shows a youth event. The groups of girls in varying uniforms were likely part of cheer or drill teams that were assembled for a parade. (STHS.)

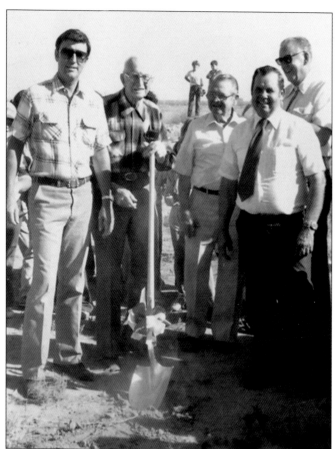

This photograph shows the ground-breaking ceremony for the new Queen Creek Elementary School, which opened in 1982. For 57 years, Queen Creek children attended the Rittenhouse School, which became the Queen Creek School in 1947. Attending the ceremony were former school board members (from left to right) James Sossaman, Charles Brandon, Donald Ellsworth, Newell Barney, and Homer Elledge, the former principal. The students also attended the ceremony. (STHS.)

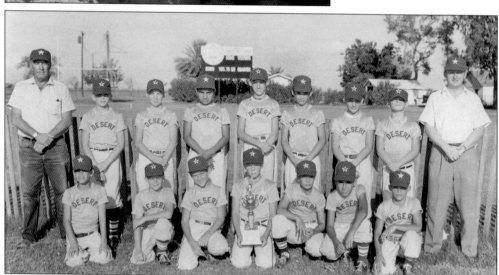

The Queen Creek Farm Bureau sponsored the winning baseball team in the Desert Little League in 1956. The Queen Creek team played 20 games and posted an 18-2 record. Games were played on the Church of Jesus Christ of Latter-day Saints ball field. The team used the Queen Creek school bus for transportation. (STHS.)

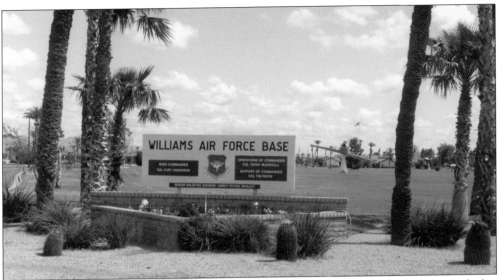

Williams Air Force Base opened in 1941 northwest of Queen Creek. The base was named after Charles Linton Williams, an Arizona pilot who died in an aircraft accident in Hawaii in 1927. The facility was the country's first jet training base. The annual open house event, known as Willie Day, offered area residents an opportunity to learn about the facility and watch the Air Force Thunderbirds perform. (STHS.)

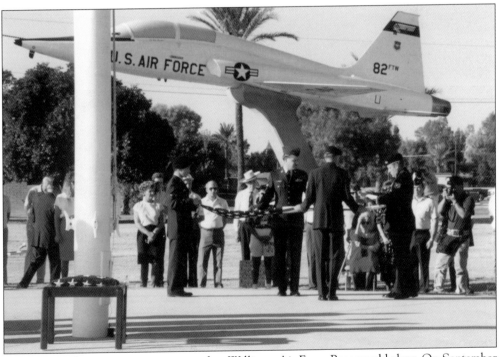

In July 1991, the announcement came that Williams Air Force Base would close. On September 30, 1993, it officially closed with the last flag-lowering ceremony. Mesa mayor Willie Wong received the flag. The base was within the Mesa city limits, but Queen Creek became a part of the intergovernmental group that planned for the reuse of the former base. (STHS.)

The Queen Creek Ward of the Latter-day Saints Church's women's softball team had a winning year in 1980. They received the Gilbert Stake All-Around Athletic Award. The team included, from left to right, (first row) Sandi Cummard, Leslie Hathaway, Charlotte Wilson, and an unidentified teammate; (second row) Kathy Melfy, Myrna Titsworth, Karen Missledine, Norma Matheson, and Lynette Shelley; (third row) two unidentified team members. (Gloria Greer.)

The John Deere feed wagon pours grain out to a herd of dairy cows at feeding time. The cows were also fed hay. The Greer Dairy, located at Higley and Riggs Roads, was owned by Phillip and Gloria Greer and operated from 1972 to 1998. The dairy started with 120 cows and grew to a herd of 450. The farm's acreage was eventually sold for future development. (STHS.)

Ernest Hawes was born in Tempe in 1904. He graduated from the University of Arizona in 1926 and farmed in Tempe and Eloy before coming to Queen Creek in 1937. Although he grew various crops, Hawes was especially successful in growing the Red Pontiac potato. In the 1950s, he invented a mechanical potato harvester that eliminated the stooping and lifting that had accompanied the job. The Hawes Packing Company was in the vicinity of Ellsworth and Rittenhouse Roads. The Hawes farm once covered four square miles, from Power Road to Hawes Road and Ocotillo Road to Riggs Road. In the 1970s, Hawes began to subdivide the ranch into one- and two-acre parcels, and it eventually became the Rancho Jardines development. Ernest Hawes died in 1986. (Both, STHS.)

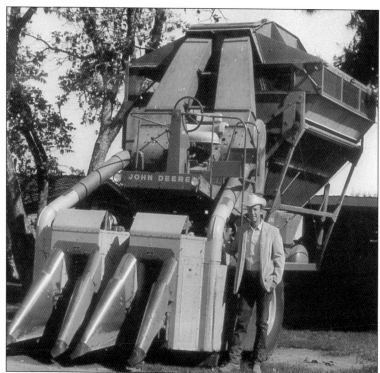

James Sossaman, a third-generation Arizona cotton grower, chose a life of farming and politics. The Sossaman family farm has grown cotton, grain, alfalfa, and potatoes. Sossaman served for over 20 years in the Arizona legislature and for 15 years on the Queen Creek School Board. Today, the continued operation of the farm keeps Queen Creek's agricultural heritage alive. (TOQC.)

An earlier entryway into Schnepf Farms is seen here in 1998. The farm is located on the southeastern boundary of Maricopa County. The billboard on the right announces upcoming events such as the annual Potato Fest and the Country Thunder music festival. In the Phoenix metropolitan area, Schnepf Farms is known for its annual events and farm produce. (TOQC.)

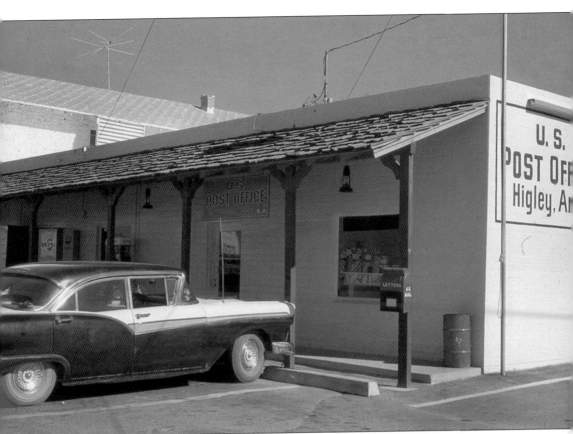

The Higley post office was established in January 1910, when Arizona was still a territory. Lawrence Sorey was appointed postmaster. The post office was located inside a general store on the southwestern side of Higley and Williams Field Roads. When the first rural route was created in 1915, Sorey's daughter Matilda became the first mail carrier. The Higley post office also delivered mail to the Queen Creek area from 1916 to 1947. A new post office building was later constructed on the same site. In 1989, another new post office was built on the northeastern side of Higley and Ray Roads. The old post office building was demolished in 2012. When this photograph was taken in 1968, Lillie McEntire was postmistress. She and her husband, Roy, moved to Higley in 1929 and operated a garage and service station. During World War II, Lillie operated a laundry behind the service station, providing laundry service for the servicemen at Williams Air Force Base. She was the postmistress for 23 years. (Photograph by Robert Bechtel; courtesy of the Postal History Foundation.)

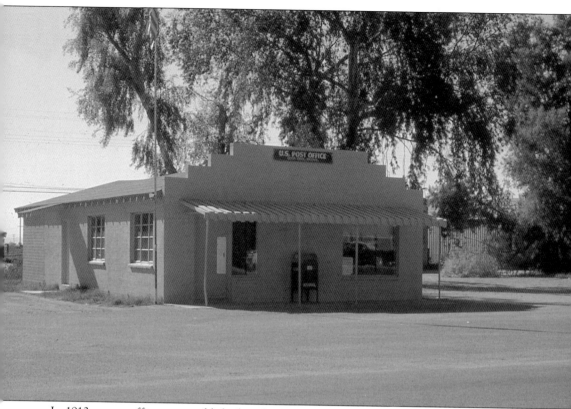

In 1913, a post office was established at the Queen Creek switch, located at Rittenhouse Road south of Cloud Road. Frank E. Ross was appointed postmaster. Delivery was discontinued in 1916, after which mail was delivered by the Higley post office. Leo Ellsworth reestablished the Queen Creek post office in 1947. The fourth class post office was located in a corner of the Queen Creek Fountain & Drugstore, also owned by Ellsworth. Eva Lena Eddy became postmistress. In the 1960s, the community received a new post office, seen here in 1968. Retta Thompson served as postmistress from 1958 to 1973. Thompson was born to Mormon pioneers in Mesa in 1905 and moved to Queen Creek in 1954. The new Queen Creek post office opened in 1987 on Ellsworth Road. The previous building still stands and is currently Dos Arbolitos Imports. (Photograph by Robert Bechtel; courtesy of the Postal History Foundation.)

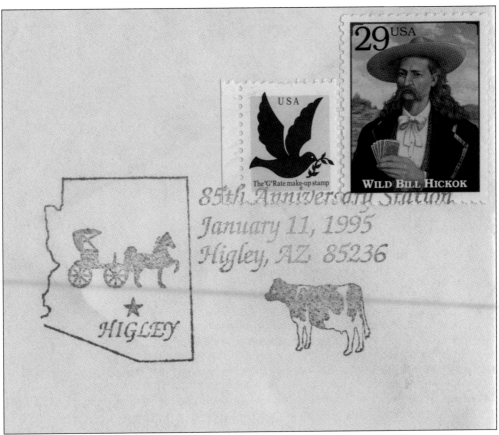

Individuals and organizations can request a commemorative cancel from the US Postal Service to celebrate a special event. They must provide the design for the cancel, which must be dated and include the name of the event accompanied by the word "station." A temporary postal station set up at the event will provide the cancel on envelopes or postcards with first-class postage. The commemorative cancel above was made to honor the 85th anniversary of the Higley post office on January 11, 1995. The first post office opened in 1910, when Arizona was still a territory. The commemorative cancel below celebrates the Country Jam USA music festival, which was held for the first time in Queen Creek on April 8, 1994. (Both, STHS.)

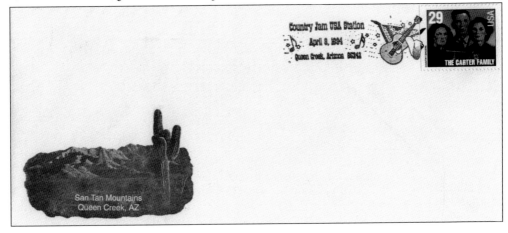

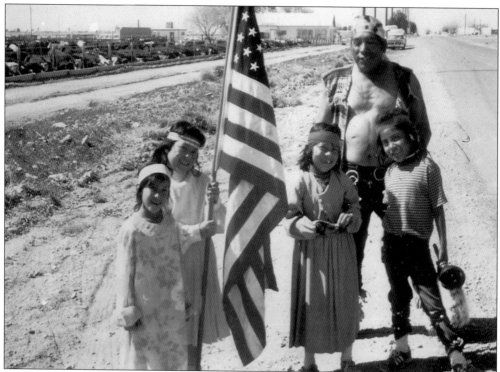

A Native American family poses on the south side of Ocotillo Road, west of Ellsworth Road. They are, from left to right, Gloria James, Lisa James, Cecilia James, Daniel Wish, and Mike Wish. The stockyards are visible behind them. The photograph from the early 1970s notes that the group is in front of what was later developed as the Will Rogers Equestrian Ranch in 1998. (STHS.)

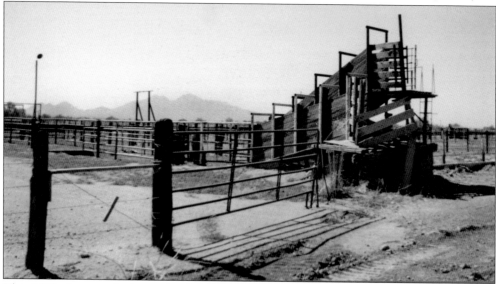

This 1995 photograph shows the abandoned loading chute and feedlot on the south side of Ocotillo Road, east of Hawes Road. The site was the last reminder of the Queen Creek cattle industry, which was begun by Leo Ellsworth in the 1940s. The area was later developed into the Will Rogers Equestrian Ranch in 1998. (STHS.)

The judges for the equestrian division of the 1998 annual Christmas parade were, from left to right, unidentified, Eva Lena Koepnick, and Max Koepnick. Eva Lena was an accomplished horsewoman who performed with the Quadrille De Mujeres, an equestrian drill team. When the Queen Creek post office was reestablished in 1947, she became postmistress. She was also a past president of the Queen Creek Desert Diggers garden club. (TOQC.)

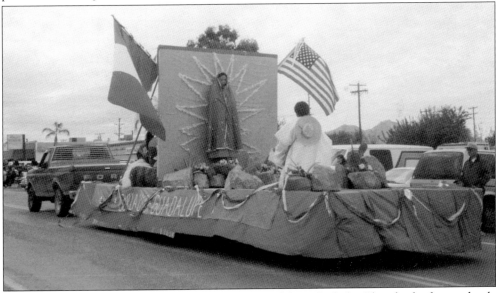

This parade float was sponsored by Our Lady of Guadalupe Catholic Church, the first and only Catholic church in town. The float depicts the apparition of the Blessed Virgin Mary to the peasant Juan Diego in Mexico. Also displayed are the flags of the United States and Mexico. (Sylvia Acuña.)

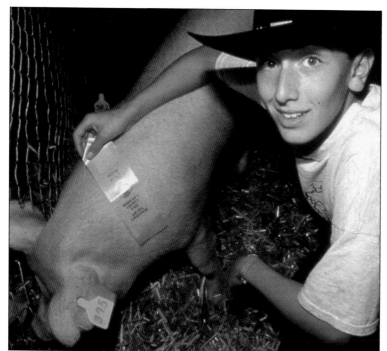

The mission statement of the Arizona Boys Ranch reads, in part, "To help troubled boys develop self-respect and self confidence, to provide them with vital social, educational and vocational skills." To this end, the boys at the ranch participate in athletics, 4-H, and choir activities. This student shows his award ribbon for 10th place in the 4-H livestock division at the Maricopa County Fair. (TOQC.)

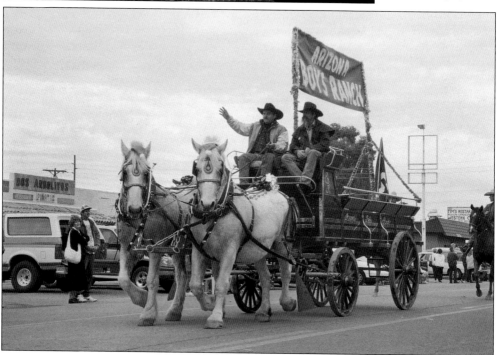

The Arizona Boys Ranch participated in the 1998 annual Christmas parade. Through the years, the Boys Ranch has supported town events with volunteer help and supported clubs by providing meeting rooms. Their annual fall open house and barbeque for the Queen Creek community was a tradition for residents. When a larger venue was needed for the annual Fourth of July celebration, the school hosted it for two years. (TOQC.)

Standing at the Pork Shop Brat Barn are, from left to right, Greg Combs, Bill Combs, Matt Harrison, and Tony Combs. In the 1940s, Bill and Doris Combs began farming on 640 acres of desert land in the Queen Creek area. They raised cotton, grains, cattle, and hogs. Bill and Doris were Thunderbird 4-H Club leaders. The club sponsored the annual 4-H pie auction to raise funds. (Greg Combs.)

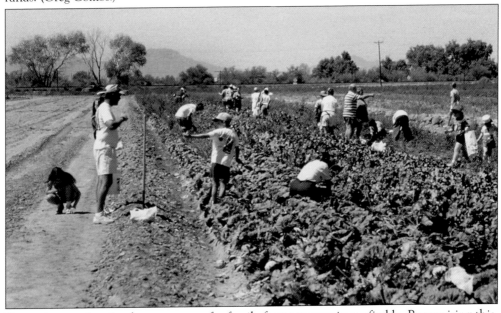

Entertainment farming became a way for family farms to remain profitable. Recognizing this, Schnepf Family Farms has been successful in inviting Arizonans to their home to learn about and participate in the farming experience. Their largest festival is the annual Pumpkin and Chili Party, held in October. Visitors enjoy the opportunity to harvest their own produce. School tours of the farm are also popular. (TOQC.)

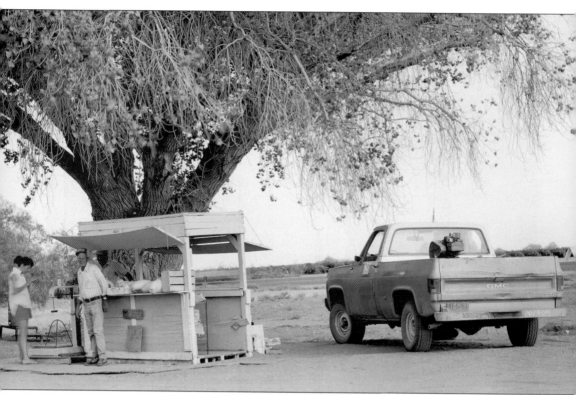

Sarah and James Oliver Power arrived in Arizona in 1894 from the Midwest, living in Florence and Bisbee. In 1917, they moved to the Queen Creek area. They had 13 children, several of whom attended the Queen Creek School. Initially, their homestead, west of Sossaman and Ocotillo Roads, consisted of 320 acres. More land was then purchased, and the Powers eventually acquired 3,000 acres to raise cattle on. The property was mainly from south of Rittenhouse Road to Ocotillo Road and west of Power Road to Recker Road. Power Farms raised potatoes, cotton, grain, and produce. All products had to be sent to Mesa for packing and shipping. In the 1970s, fruit trees and grapes were also grown. A fruit-packing shed was built on the corner of Power and Rittenhouse Roads. Kent Power is seen here minding his produce stand in the summer of 1988. The bumper sticker on his truck reads, "As a matter of fact, I do own the road." Kent Power died in 1997. (STHS.)

Keith, Kent, Wilbur, and Ivan Power all remained on the farm. Locally, they became known as the Power Boys. In the following years, the brothers grew cotton, grains, potatoes, table grapes, pigs, and cattle. Later, peach, plum, apricot, and grape orchards were open to the public to pick their own farm-fresh fruit. The first stop was the produce stand (above), south of Rittenhouse and Power Roads, to get directions to the orchard and advice on fruit picking. Many residents in surrounding areas have fond memories of picking fresh fruit in the Queen Creek area. By 1997, the 3,000-acre Power Ranch had been sold to be developed into a master-planned community named Power Ranch and an active senior community called Trilogy. (Both, STHS.)

Joyce Hicks married Kent Jackson Power in 1949 and they had four children. Their oldest son died at age seven in a drowning accident. They built a home on the west side of Power Road, north of Ocotillo Road, on land given to them by Kent's father. In the article "Joyce Power Reflects" in the February 2002 *San Tan Monthly*, Mary Pierce Bale wrote, "Beef dropped so low in price in the 1960's and 1970's that it became less and less profitable to raise cattle and grow their own feed on the ranch. So the family grew peaches, plums, apricots, grapes as well as potatoes and cotton. When they plowed up the land to change from desert to fruit farming, more artifacts were found. All these artifacts along with hunting trophies and other treasures are preserved in display cases or mounted appropriately in a special room at Joyce's home." (STHS.)

Five

QUEEN CREEK
SCHOOL YEARBOOK

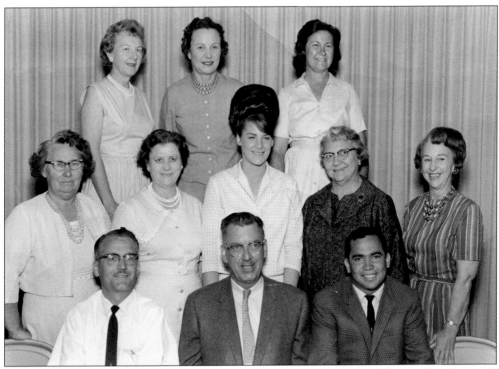

In 1965, the Queen Creek Elementary School faculty included, from left to right, (first row) Torris Gjerde, Homer Elledge, and Joe Arredondo; (second row) Mary Lewis, Rachel Edwards, Jan Hancock, Caroline Johnston, and Lena Lines; (third row) Joyce Yontz, Inez Wingfield, and Joyce Power. Elledge served as superintendent for 25 years, from 1952 to 1977. In 1947, Queen Creek School was designated as District 95. (STHS.)

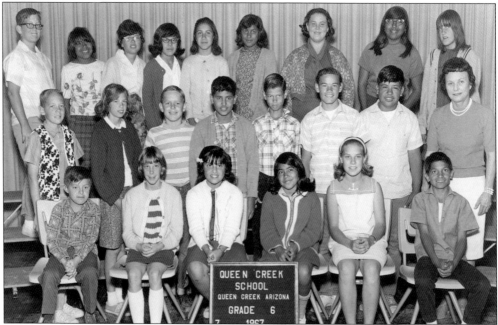

Inez Wingfield taught sixth grade at Queen Creek School for many years and is seen here with the classes of 1967 (above) and 1962 (below). She was also the editor of the school's weekly newspaper, the *Queen Creek Spudder*. The name referred to Queen Creek's reputation as a top potato-producing farming community. Her student reporters collected information and wrote news articles for the one-page publication. The weekly cafeteria lunch menu was always featured in the middle of the paper, with school news items filling the remaining space. Some of the regular features were accounts of field trips and holiday celebrations. Reports on the sports teams and honor roll mentions were also included. January brought a column on class resolutions. Superintendent Homer Elledge also used the publication to communicate with students. (Both, STHS.)

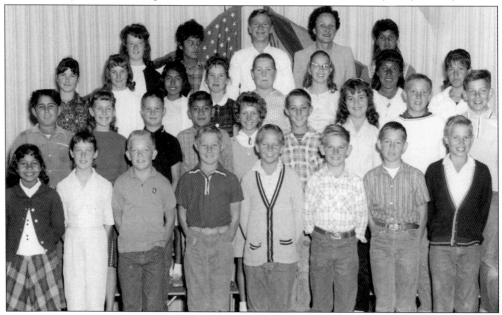

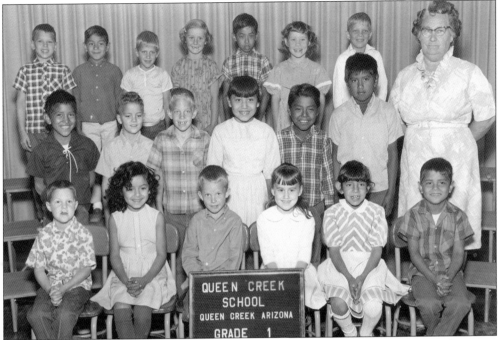

In the early 1960s, the Queen Creek School underwent building improvements. All of the rooms were repainted, closets and bookshelves were added, electrical work improved lighting and air-cooling, the auditorium underwent a major improvement, the long windows were eliminated, new lights were installed, and teachers chose new curtains. The school held a dedication assembly for the redecorated auditorium. The December 1960 issue of the *Queen Creek Spudder* reported, "Mr. Elledge announced our auditorium was completed since the new curtains had been installed. The assembly was ended with a prayer from Reverend Johnston. All of us were glad to see Mr. Barney and Mr. Brandon of the school board present." (Both, STHS.)

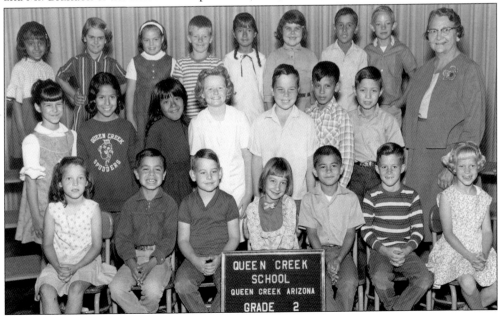

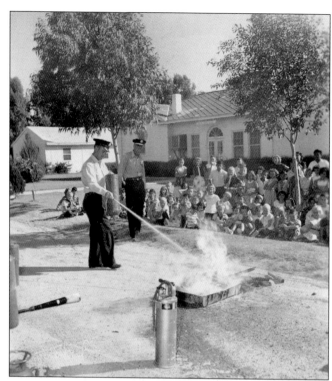

The October 12, 1951, issue of the *Queen Creek Spudder* reported, "Fire Prevention Week was observed last Friday by Queen Creek School at an all school assembly which featured a demonstration by the fire fighters of Williams Field under the direction of Chief Anderson. Four of the upper grade boys had the honor of putting out a bonfire set by the firemen." (STHS.)

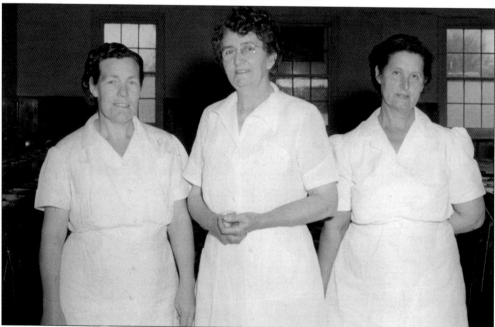

Early cafeteria staff members at the Queen Creek School included, from left to right, Mrs. Braisher, Mrs. Elledge, and Mrs. Bunch. Faith Sossaman and Bertha Vest organized the first cafeteria in the 1940s, using a small building on the school grounds. Vest obtained discarded kitchen utensils and cookware from the Chandler School's cafeteria. Later, Queen Creek School purchased a barracks to use as a cafeteria. (STHS.)

The 1962 Queen Creek School "A" basketball team included, from left to right, (first row) Gail Barney, Socorro Morales, Wayne Van Allen, Jerry Mecham, and Gary Daniels; (second row) coach Lyle Ellsworth, Jerry Gunter, John Steele, John Ethington, Harold Dandridge, and Larry Morrow. The school played games against Combs, Apache Junction, and Higley schools. (STHS.)

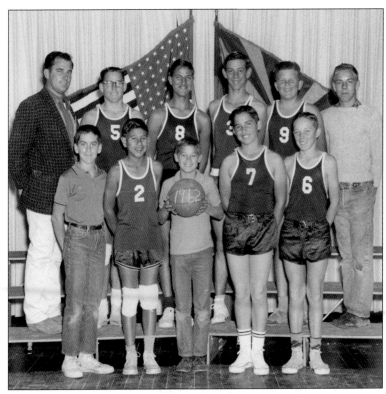

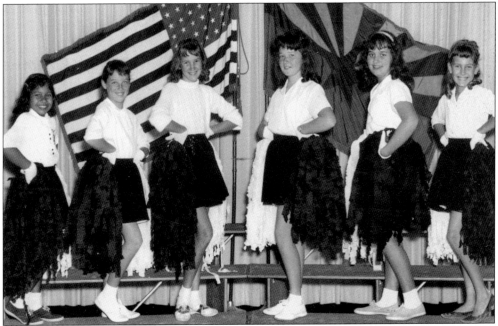

The 1962 Queen Creek School junior cheerleaders from the sixth grade included, from left to right, Delia Morales, Dyann Mecham, Gloria Young, Terry McEntire, Brenda Barney, and Nancy Hastings. In a cheerleading contest held that year at the school, the junior group won second place in a competition against the seventh- and eighth-grade cheerleaders. (STHS.)

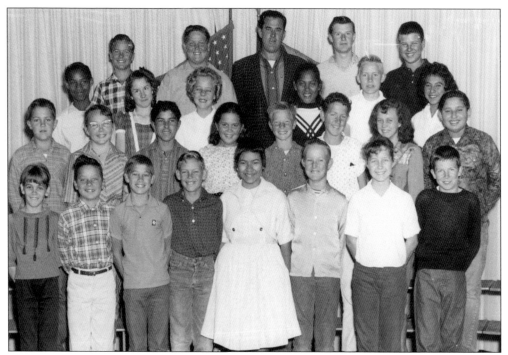

The September 20, 1962, issue of the *Queen Creek Spudder* reported, "The seventh and eighth grade students were invited to attend the opening of the Western Cotton Products Company. When the students arrived, a photographer took their picture and the group was served refreshments before they were taken on a tour of the plant." In another issue of the school newspaper, Shirley Berlin wrote, "We live in a part of the country where the raising of cotton is important, so we thought it was wonderful to visit the Queen Creek Cotton Gin. There are two gins there—one is for long staple cotton and one is for short staple cotton." (Both, STHS.)

The Queen Creek School bus drivers in the 1961 photograph at right are, from left to right, R.M. Morris, Lyle Ellsworth, and Paul Mitchell. Ellsworth was also a teacher and a coach. The school maintained three school buses. A truck and an automobile were also available for transportation. The bus garage was located south of the school building. Besides transporting the children to and from school, the buses also provided transportation for sports teams and class field trips. The students visited the Tempe Rock Garden, the Arizona State Capitol, Alligator Farm in Mesa, the Arizona State University Planetarium, and the Cudahy Packing Co. plant in Phoenix. (Both, STHS.)

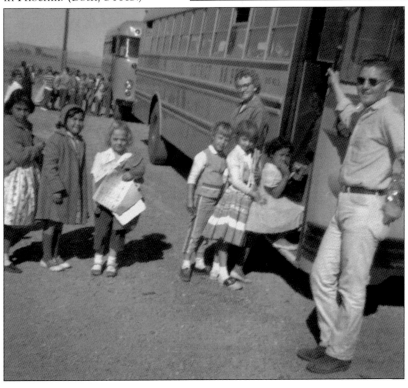

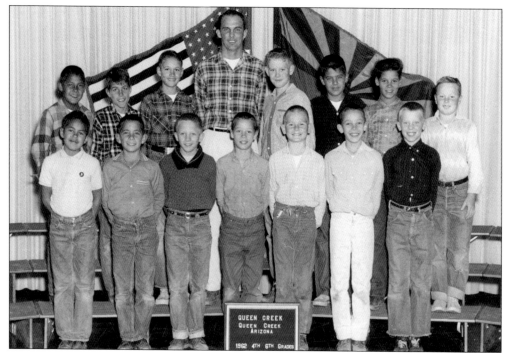

Elden Walters began teaching physical education at Queen Creek School in 1959. He also taught classes at the Arizona Boys Ranch. In 1962, he taught fourth- and sixth-graders at the Boys Ranch. In the early years of the ranch, the boys attended Queen Creek School. (STHS.)

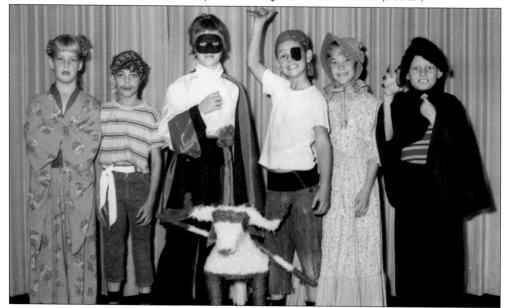

The October 1964 issue of the *Queen Creek Spudder* reported on the Halloween carnival. Bobby Elledge wrote, "Friday, October 30 starting at five o'clock will be our school carnival. Why not have some fun and wear a costume? Everyone wearing a costume will receive a small prize." Seen here in costume are, from left to right, Marilyn Barney, unidentified, Patsy Elledge, unidentified, Angela McCain, and Jimmy Brandon. (STHS.)

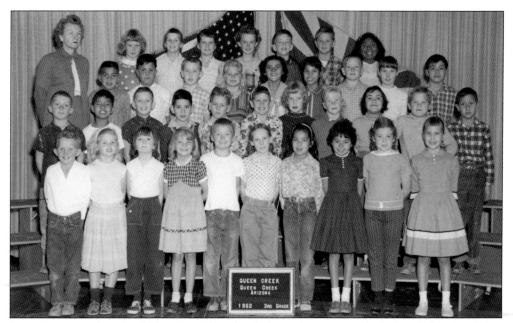

Joyce Yontz was the school librarian. The school library first consisted of a few shelves inside her second-grade classroom. In later years, it moved to one of the barracks buildings, where other classrooms were also located. Yontz borrowed library books for students from the Maricopa County Library, the extension service, and the Phoenix Public Library. (STHS.)

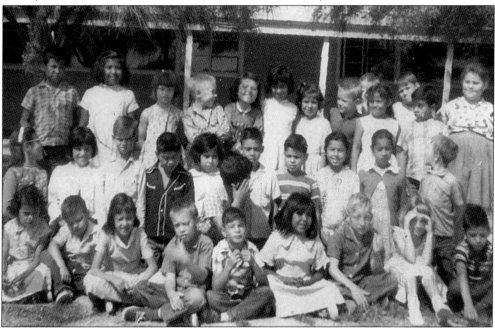

The first-grade class poses for an informal photograph in 1961 in front of the Queen Creek School cafeteria. With its many different faces and expressions, the photograph reflects the demographics of the community. Identified are Dub Gamel (second row, third from left) and Donna Abbott (third row, far right). For lunch, the children were often served meatloaf, tuna salad, spaghetti, or fish sticks. (Shirley Lane.)

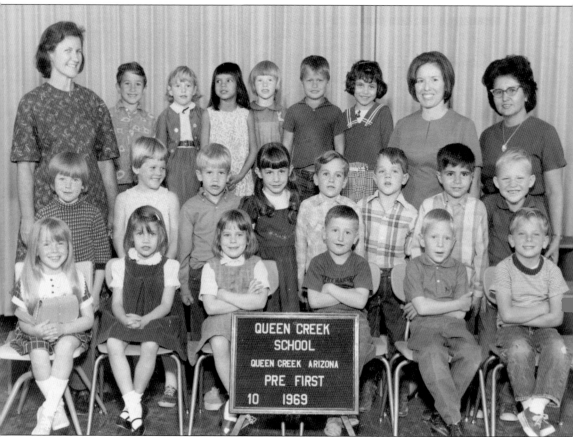

Preparatory First Grade, or Pre-First, was a new school program that began in 1966. The program gave five-year-old children a wider range of experiences. There were morning and afternoon groups. Children did not have to live in the school district to attend, and there were no income requirements. Their playground was separate from the older students' playground. Joyce Power (third row, left) was the teacher. Her teacher's aides were Theresa McHaney (third row, second from right) and Maria Esparza (third row, far right). Power kept a scrapbook of her 1969 class. The children celebrated all the holidays with special crafts and foods. They visited the Power Brothers' fruit groves during apricot blossom time and went to the Phoenix Zoo. The children also painted and planted gardens. Visiting nurses checked their ears and teeth. Power started a parent participation program for the mothers of the children. She was also a music teacher who played piano. She taught at Queen Creek School for 17 years. (STHS.)

Edited by Frances Brandon Pickett, the book *Histories and Precious Memories of Queen Creek, Chandler Heights, Higley and Combs Areas, 1916–1960* gives first-hand accounts of living in the Queen Creek area from early residents. Maurine Cluff recalls her experiences as a teacher, "We had many fun events at the school: Halloween carnivals, Christmas programs, art exhibits, fashion shows, Track and Field Days, trips to Tonto National Bridge and trips to Disneyland. I had fun being the gypsy fortune teller at the Halloween Carnivals. Newell Barney loaned me his tent and I decorated it with Christmas lights and sat at my table with my crystal ball and looked into the past, present and future." (Both, STHS.)

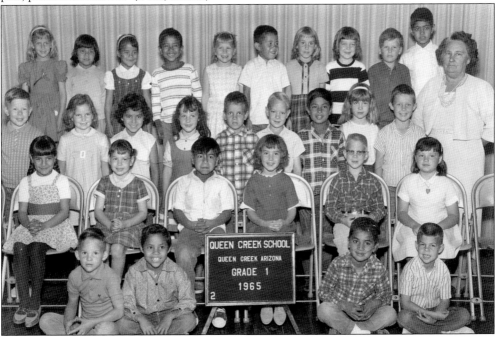

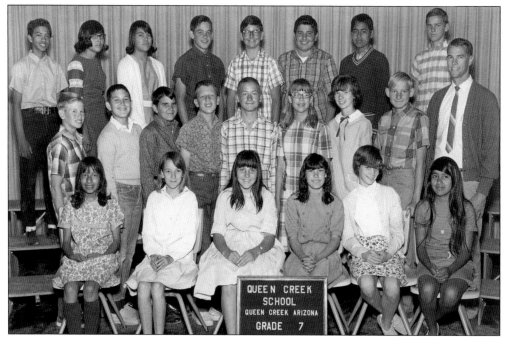

The seventh-grade instructor was Glenn Woods. An annual tradition at the school was the seventh- and eighth-grade banquet. The school newspaper reported, "Invitations were sent out this week for the seventh-eighth grade banquet. The eighth grade students and their parents are invited as guests. The seventh grade mothers prepare the food. The seventh grade acts as hosts, so they plan the decorations, menu and program. During the dinner the class wills and prophecies will be read as part of the dinner program. After the banquet everyone will go to the auditorium where a fashion show will be presented." (Both, STHS.)

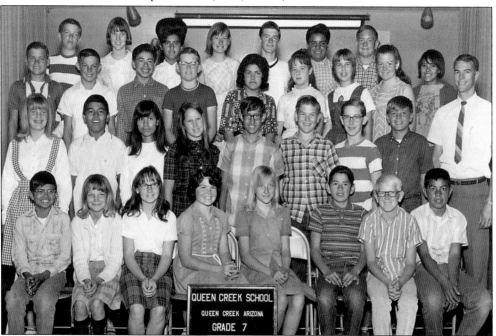

Superintendent Homer Elledge wrote about the school honor roll in the 1962 school newsletter. He said, "Since its beginning three years ago, the distinction of being named to the school honor roll has been one of the achievements most eagerly sought after by students of Queen Creek Elementary School. The honor roll which this year will be limited to grades four through eight has been a challenge even to the most gifted pupil. To be eligible, a pupil must maintain a two average during the six week period and in addition, must not receive a grade lower than a three in any subject, conduct included." (Both, STHS.)

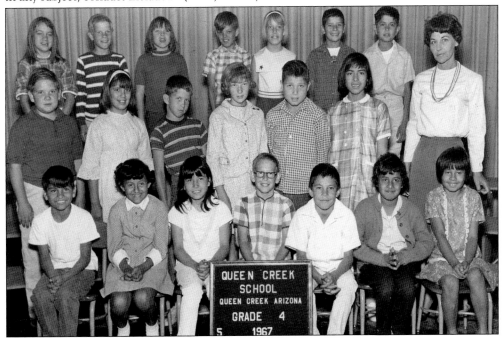

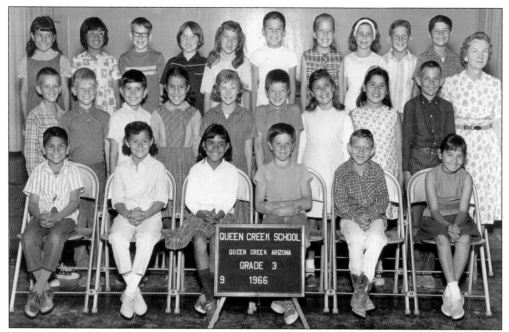

In 1966, the Arizona State Department of Education sponsored a reading contest for all of the students at the Queen Creek School. Students received a certificate of merit for reading 20 books. The department also sponsored a creative poetry contest open to all grades. Any student could submit an original poem on any subject. (STHS.)

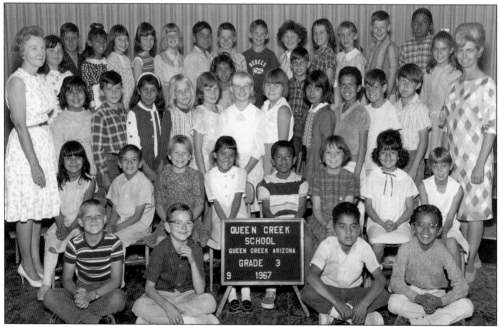

The 1967 Queen Creek School third-grade class became seventh-graders in the 1970–1971 school year, when they hosted the annual seventh- and eighth-grade banquet for the outgoing class. In 1971, the school had 14 faculty members. Pauline Bryant was the cafeteria manager and Ervin Lee was the bus driver. (STHS.)

The eighth-graders at Queen Creek School graduated on Wednesday, May 21, 1975. The ceremonies were held in the school cafeteria. Graduating with honors were Lawrence Quintero, Josephine Leal, Mary Nevitt, Roselio Sosa, Dessiree Evans, Ernesto Camacho, Jonathan Fox, Mark Parker, and Gilbert Olaquez. At the graduation, the Glee Club sang "America Our Heritage" and "Children's Prayer." (STHS.)

When Jim Bronston's fifth-graders graduated on May 24, 1978, the guest speaker at their ceremony was Sen. Barry Goldwater. Geraldine Barney was the class valedictorian and Tambra Parkhurst was the salutatorian. Newell Barney, the president of the board of trustees, presented the diplomas. (STHS.)

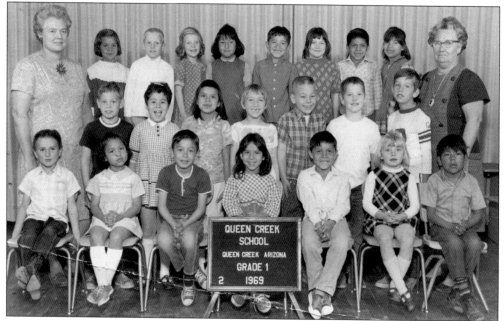

Frances Pickett (standing, left) began working at the Queen Creek School as a teacher's aide. She had attended the same school as a child. When Mary Lewis retired, Pickett replaced her as the first-grade teacher and an art teacher. She organized the annual arts and crafts show for the students. She retired in 1985 after a 19-year teaching career. (STHS.)

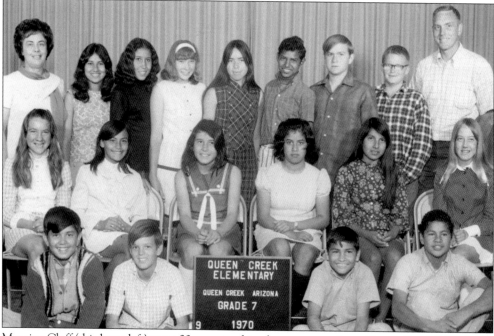

Maurine Cluff (third row, left) spent 23 years teaching home economics at Queen Creek School. She also taught English and Spanish classes. An old shop room was remodeled and became the home economics building. The sixth-, seventh-, and eighth-grade girls modeled their new dresses at a fashion show held after the annual seventh- and eighth-grade banquet. Cluff retired in 1982. (STHS.)

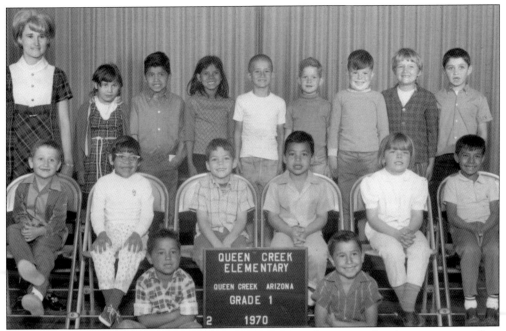

In 1970, six-year-old first-graders would have started their education in kindergarten at age five. The 1970s introduced four-year-olds to the preschool program. In 1972, Queen Creek Elementary School received a federal education grant to implement a preschool program. Jean Leak was the teacher and Cruz Valenzuela was the assistant. They received initial and ongoing special training. Queen Creek had one of only five preschool programs in Arizona. The new teaching concept was to help children learn and explore through their senses. A cement-floored storage garage was improved for class use. In the first year, 22 preschoolers participated in the successful program. (Both, STHS.)

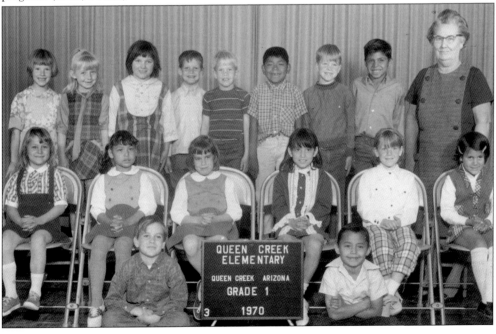

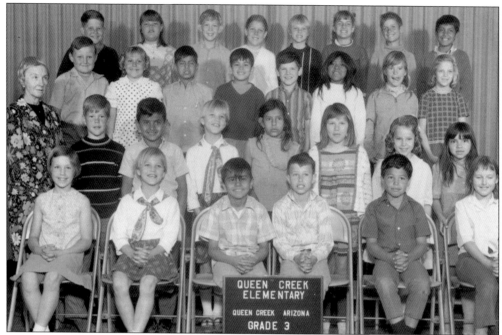

Under superintendent Homer Elledge, enrollment at Queen Creek School grew from 270 in 1951 to 450 in 1977. Through the years in the small school, children had opportunities to work for the school newspaper, join the glee club, and help in the cafeteria. They had a school band, a school nurse, and school buses. In *Histories and Precious Memories*, Duane Schnepf recalls, "Though we might not have fancy facilities, we never did without the important things that the students needed. There was a great togetherness and spirit that we experienced as the students, parents and administrators worked together to accomplish our education." (Both, STHS.)

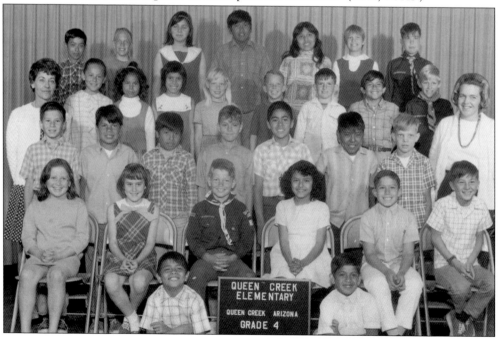

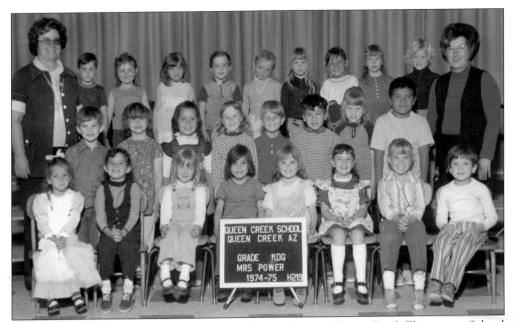

Joyce Power (standing, left) retired in 1978 after teaching at Queen Creek Elementary School for 17 years. She started as a kindergarten teacher and later taught the third grade. Power was honored at a faculty staff luncheon and presented with a plaque from the board of trustees. The students presented her with a rocking chair. (STHS.)

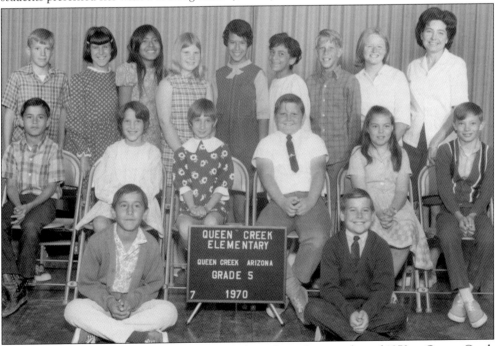

The fifth-grade class in 1970 became the eighth-grade graduating class of 1973 at Queen Creek School. At the annual seventh- and eighth-grade banquet that year, dinner was prepared by the mothers of the seventh-graders. The eighth-graders voted for Marty Pina as most popular boy and Kathie Bracken as most popular girl. (STHS.)

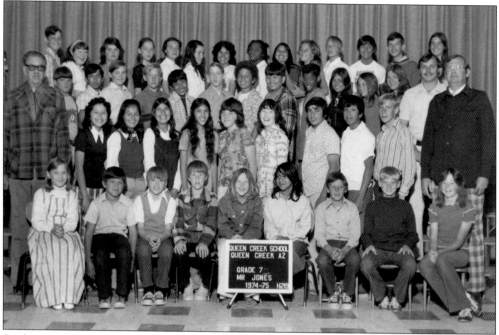

Students at Queen Creek School in the 1970s brought the school to the end of an era. Superintendent Homer Elledge (standing, far left) retired in 1977 after a 25-year career. Elledge filled many roles at the school, including teacher, principal, custodian, and bus driver. The school grew from three to seven buildings, with a library and a reading lab, during his tenure. Ralph Pomeroy succeeded Elledge. A few years later, construction began on a new elementary school for 1982. This began the process for the school system to grow and include a separate junior high school and high school. Pomeroy was superintendent for 17 years. (Both, STHS.)

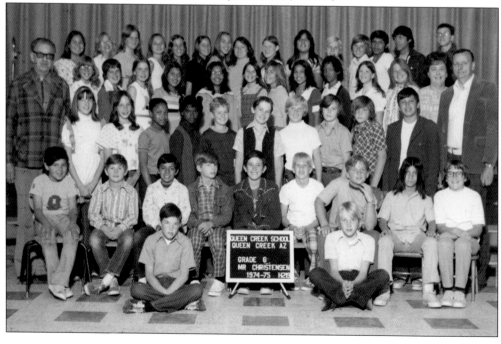

This annual kindergarten class photograph shows teachers (standing, from left to right) Nadine Brimhall, Barbara Welborn, and Geraldine Barney. In the 1981–1982 school year, Barney chronicled her experiences as a kindergarten teacher aide to Brimhall. She had joined a high school career exploration club to acquire experience in her potential field of interest. Barney wrote, "The enrollment for kindergarten is 53 students. I help with the afternoon session and there are 26 children in the class. Queen Creek is now in the process of building a brand new elementary school. It should be completed for the 1982–1983 school year. Mrs. Nadine Brimhall and Mrs. Barbara Welborn are the two ladies I work directly with. They have shown and taught me so much. Working with children is what I really enjoy doing. It makes me feel good to think I may be helping a child to learn. This class is a very special one." (STHS.)

After working hard in the classroom, kindergartners spend time on the playground. Geraldine Barney observed, "After recess the children wash their hands before going in for their snack. Every day the helpers and I go to the cafeteria and get the milk and crackers for the snacks. On special days we may have something else. At Thanksgiving time, we had pumpkin pie." (STHS.)

Members of the 1981–1982 kindergarten class enjoyed a field trip to the Greer Dairy, where the children learned how to milk a cow. Barney also described another field trip to the zoo, writing, "Both kindergarten classes went at the same time. We saw a puppet show, saw most of the animals and rode on the tram. Olga, Donna and Michelle [from left to right] were all happy and posed for the camera." (STHS.)

Children are seen here enjoying the holidays. Geraldine Barney remembers, "Halloween was such a fun time. Everyone dressed up. The day was full of activities. We had a party. The elementary part of the school put on a parade for parents and the older students. Kindergarten even got to lead it. That night we had a carnival with games, prizes and fun. Christmas was really exciting. Both kindergarten classes came in the morning. We had a visit from Santa Claus. He arrived in a helicopter. The children loved it. Santa then came into the room and visited with each child." (Both, STHS.)

Carolyn Tanner's third-grade class visited Pioneer, Arizona, in the 1980s. Brandon Pearce, a student in her class, wrote of the photograph above, "We took a picture of Richard because it is his 9th birthday on the field trip. We saw an old lady. She told us about the cabin and when it was built." Custodian Curtis Rowe drove the school bus. Pioneer, Arizona, is located north of Phoenix and features a living history museum; a replica of an early pioneer village set at a time when settlers and explorers began to move into the Arizona territory. Afterwards, Tanner's students wrote about their experience. Mark Vacaneri wrote about the photograph below, "Here are four crazy kids in front of a pomegranate tree and beside the garden on the front wall. The crazy kids are named Jesus, Tyler, Jose and Brandon. They are just about straight across from the Northern Arizona House." (Both, STHS.)

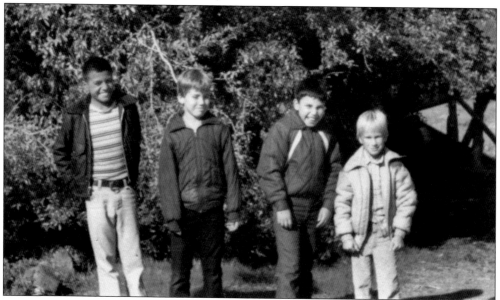

Carolyn Tanner's third-graders visited the barn, the corral, and the schoolhouse at Pioneer, Arizona. Brooke Mull wrote about the photograph below, "Ann, Reed, Denise, John, Patricia, Mark, Brandon, Jason, Amanda and I were standing in front of a rock wall. There is a corral with a horse and a cow in it. We looked at all the houses the pioneers had. We saw the school too. It had lunch boxes in it. The children built a house for their teacher. It was a nice day to go on a field trip." Ann Sloup wrote, "When we went to Pioneer Arizona, we saw an old school. Mrs. Tanner took a picture of our class on the porch. I like the house with nothing in it but it had a board in it with milk jugs on the board. It was built over a stream. I also liked the blacksmith." (Both, STHS.)

Queen Creek Elementary School District 95 became Queen Creek Unified School District 95 in 1980. The new designation opened the way for the school system to add higher grades. The 1981–1982 school year added the first ninth-grade class in Queen Creek. The junior high school received accreditation. In 1985, the first 10th-grade class was added. In consecutive years, 11th- and 12th-grade classes were added. The 1980s brought increased building activity, with the addition of offices, the upper grade building (above), and a new gym (below). In 1986, the Queen Creek Educational Center was completed. It housed a new library, classrooms, and science labs. (Both, STHS.)

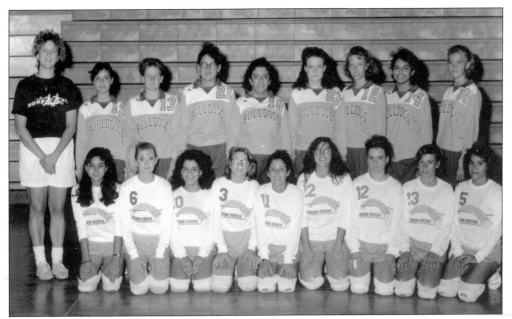

Tammy McIver (second row, far left) began coaching and teaching physical education classes at Queen Creek School in 1982. She coached volleyball, basketball, and softball. In 1986, the seventh- and eighth-grade volleyball team won the Superstition League championship. In 1989, the varsity volleyball team qualified for the state finals. In 1990, the softball team captured Queen Creek High School's first state title. (STHS.)

The youth flag football league was sponsored by the Town of Queen Creek's Parks and Recreation Department. In 1999, the league was comprised of nine teams, the largest number of teams to date. Volunteer coaches and parents participated. The town's youth programs provide opportunities for school-age children under the age of 13 to participate in sports. (TOQC.)

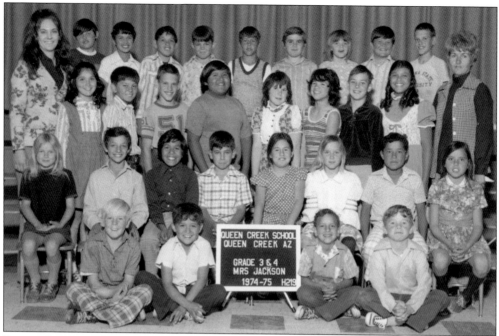

During the 1985–1986 school year, the Queen Creek educational system continued to expand by adding the first 10th-grade class, making Queen Creek High School a reality. In the following years, the 11th and 12th grades would be added. Construction started on the new Queen Creek Educational Center in 1985 and was completed in 1986. The first high school cheerleading squads were chosen and the high school celebrated its first homecoming event. The Kiwanis Club sponsored the new Key Club for 9th- and 10th-grade students. The yearbook was dedicated to Gloria McCain, who started teaching at Queen Creek School in 1965. (Both, STHS.)

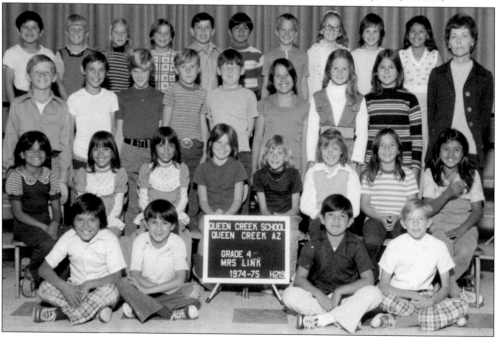

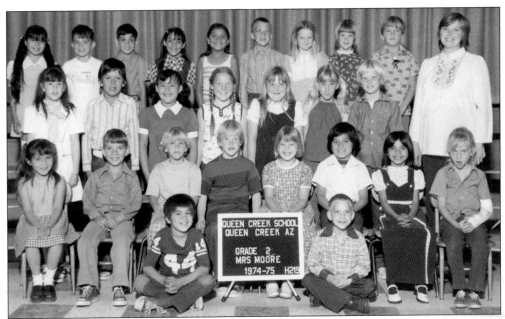

In the 1986–1987 school year, the 11th grade was added and Roger Kershner became the new principal. The monthly school newspaper, *Highlights*, began its second year. The bulldog also became the new mascot for the high school, and parents and teachers formed the Bulldog Booster Club to support extracurricular activities. The 11th-grade class planned its first junior prom, and campus improvements included the addition of a student lounge in the cafeteria. The original Queen Creek School building, or "Old Main," was renovated by the San Tan Historical Society to become a museum. And, lastly, after 10 years as the custodian of the school, Curtis Rowe retired. The best change Rowe saw was moving the children out of the barracks buildings and into a new elementary school. (Both, STHS.)

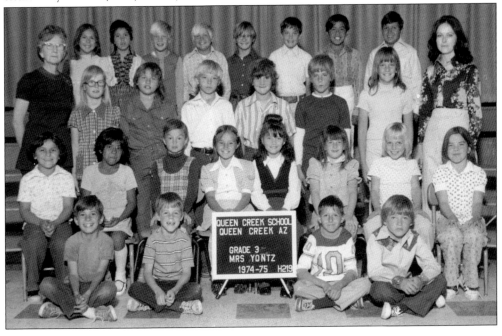

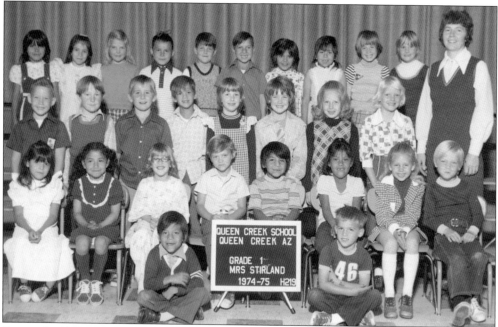

During the 1987–88 academic year, the first Queen Creek High School senior class graduated. With elementary, junior high school, and high school grades all in one location, the student population reached 800. The school newspaper was renamed the *Bulldog Edition*, and a new gymnasium was built. The high school football team won its homecoming game, the first game played on the new football field. The homecoming king and queen were Rudy Alvarado and Alice Rodriquez, and the first junior-senior prom was planned. The first senior class prepared for commencement exercises and started the tradition of the annual senior class trip. (Both, STHS.)

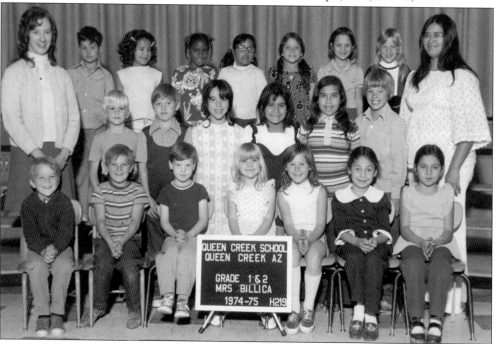

Six

SAN TAN
HISTORICAL SOCIETY

With a matching grant from the Arizona Heritage Fund, volunteers from the San Tan Historical Society began restoring the Rittenhouse School, also known as Queen Creek Elementary School and "Old Main." It was the only schoolhouse in the community for 57 years. Built in 1925, the school closed in 1982 and was used by the school district for storage space until restoration began. (STHS.)

The dedicated charter members of the San Tan Historical Society are on a mission to preserve and collect the history of Queen Creek, Chandler Heights, Higley, and Combs. Seen above from left to right are (first row) Virginia Minor, Vickie Barnes, and Alice Bates; (second row) Maurine Cluff, Wanda Downs, Mary Bendyna, Frances Pickett, Era Mae Barnes, Gloria Greer, and Donnis Hunkler. Pickett prepared a luncheon for the group at her home. Cluff and Pickett had both been teachers at the Rittenhouse School. Seen below from left to right are Sue Sossaman, Mary Bendyna, Betty Nash, and Luveda Fincher. Sossaman is the author of *Higley, Arizona: A Rural Community* and *Queen Creek: A History*. Nash was the editor of *Chandler Heights Monthly*. (Both, STHS.)

David Farnsworth stands next to the sign he made for the temporary office of the San Tan Historical Society. The office was located at the Queen Creek School District Plaza, on Ellsworth Road north of Rittenhouse Road. With a $50 allowance for wood, Farnsworth made the office sign as well as the sign for the Desert Wells Stage Stop. (STHS.)

The Desert Wells Stage Stop, on the northeastern side of Sossaman and Chandler Heights Roads, is the society's first historical site. The group received the title to the 0.75-acre site from the Rancho Jardines Development Company in May 1993. The stage stop was a rest area and water stop for horses with a 117-foot well. (STHS.)

Mary Bendyna served as the San Tan Historical Society's first president, from 1989 to 1996, after organizing volunteers to form the nonprofit organization. Under her leadership, the society received a grant from the Arizona Heritage Fund to begin restoration of the Rittenhouse School for use as a museum. Bendyna received the Town of Queen Creek's Volunteer of the Year Award in 1994. (STHS.)

Frances Pickett, a native of Queen Creek, served as the society president from 1997 to 1998. She had attended the Rittenhouse School as a child and later returned as an art teacher. After retiring from teaching in 1985, Pickett found herself at the Rittenhouse School again when she joined the San Tan Historical Society in 1990. Today, a Queen Creek elementary school is named after her. (STHS.)

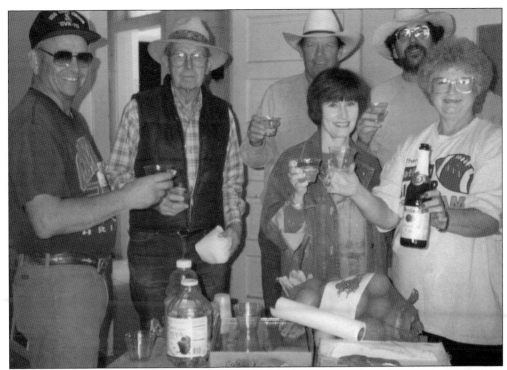

Above, on December 14, 1996, members of the society toast the new year ahead and welcome the continued work on the Old Main Stabilization Project. They are, from left to right, Phillip Greer; Ivan Cluff; Ron Hunkler, chairman of sites; Virginia Minor; Otto Sankey, project director; and Gloria Greer. On this scheduled work day, a stack of windows needing to be painted awaited them. (STHS.)

Volunteers were confronted with trouble in the boys' bathroom at the Rittenhouse School. With peeling paint, sagging fixtures, and deteriorating walls, there was much work to be done. The bathroom was renovated to become a kitchenette for the society's use. By 1998, Phase 1 of the Old Main Stabilization Project had been completed. (STHS.)

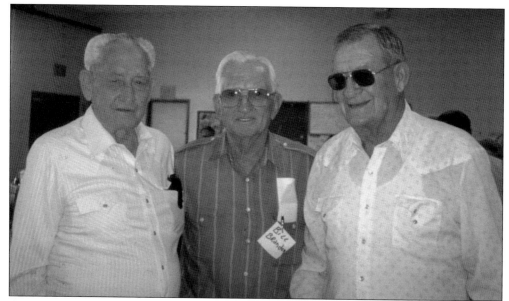

An ice cream social in May 1994 at the Queen Creek High School cafeteria brought old friends together. Seen here from left to right are Zone Bryant, Bill Brandon, and Slim Ahlquist. Bryant was a cowboy who herded cattle for Leo Ellsworth, Brandon owned the Neilson Place farm, and Ahlquist was a cowboy who became a livestock inspector. Social functions sponsored by the society continue to bring the community together. (STHS.)

With a commitment to match the Arizona Heritage Fund grant, fundraising was a standing agenda item for the society. They coordinated many successful fundraising events, including ice cream socials, stew socials, baked potato feasts, flea markets, and quilt raffles, all of which were popular events in the community. Here, Gloria Greer (left) assists the unidentified winner of a quilt raffle at the Schnepf Farms Potato Fest. Greer donated many handmade quilts for fundraising. (STHS.)

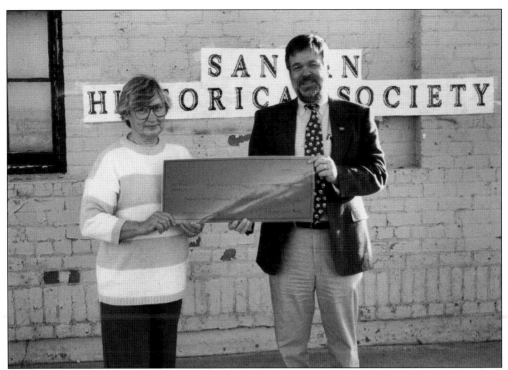

Mary Bendyna (left) accepts a check for $29,650 from a representative of the State Historic Preservation Office. The grant for restoring the Rittenhouse School was matched by the Society through cash contributions, in-kind services, and volunteer labor. Under the direction of a contractor, volunteers started working on stabilizing the deteriorated window frames. (STHS.)

When it was published in 1996, Frances Pickett's book *Histories and Precious Memories of Queen Creek, Chandler Heights, Higley and Combs Areas, 1916–1960,* was a big success. Pickett compiled over 100 histories of pioneer families. Arizona Library Binding printed 350 copies, the Arizona State Library and the Arizona Historical Society received copies, and the book was included in the Town of Queen Creek's 10th anniversary time capsule. (STHS.)

Mina Brooks (left) accepts an appreciation plaque from Frances Pickett and the historical society for her family's donation of prehistoric artifacts to the museum. Brooks often found broken pieces of Hohokam pottery along the ditch banks of her farm. When a layer of topsoil was scraped off with a tractor grader, Brooks and her husband, Robert, unearthed a large collection of prehistoric pots and bowls. (STHS.)

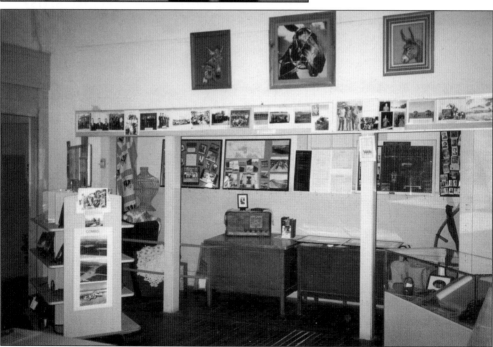

An early display in the historical museum shows the accumulation of pioneer family photographs, antique furniture, and quilts. Ongoing projects included the collection of oral and written histories from early residents and school photographs from the Rittenhouse School. Harder to locate were "Ellsworth dollars," or scrip money, issued to laborers by Leo Ellsworth. (STHS.)

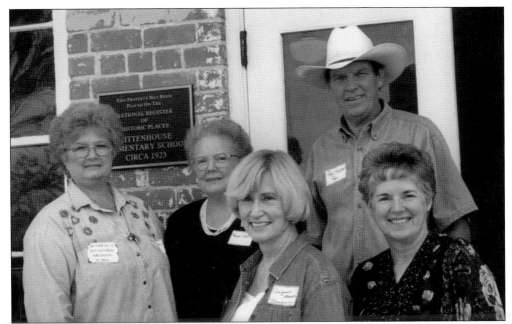

The San Tan Historical Society celebrated the addition of the Rittenhouse Elementary School to the National Register of Historic Places in 1998. From left to right are Gloria Greer, vice president; Frances Pickett, director; Virginia Minor, treasurer; Ron Hunkler, president; and Wanda Downs, secretary. The school had been added to the Arizona Historical Registry in 1990. (STHS.)

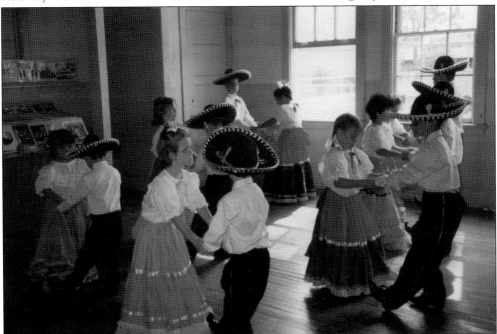

Following the unveiling of the National Register of Historic Places plaque by Frances Pickett on October 23, 1998, attendees enjoyed a tamale luncheon catered by Mary Camacho and her family. Entertainment was provided by the Queen Creek Elementary Las Aguilas Folklorico Dancers. Students and parents were invited to the ceremony. (STHS.)

Ron Truex installed a new 40-foot flagpole in front of the Rittenhouse School as an Eagle Scout project in 1999. From left to right are an unidentified assistant, Ron Truex, and Scoutmaster Jerry Bellows. The Salt River Project loaned its crane to lift the pole into position. This was the first of several Eagle Scout projects that benefited the museum. (STHS.)

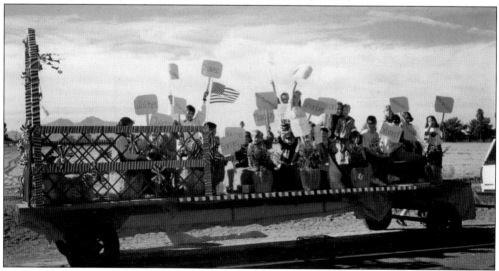

At the annual Queen Creek Christmas parade in 1994, the society won first place in the float division for their entry, with the theme "A Proud Past, A Promised Future." The float honored the founding families of the area. Placards with names like Walker, Clegg, Murdock, Chavez, Van Allen, Valenzuela, Shearwood, and Sullivan were held up by family members. (STHS.)

Betty Binner Nash is recognized by Queen Creek mayor Mark Schnepf at the annual Volunteer of the Year awards ceremony in 1997. Nash was the editor of *Chandler Heights Monthly*, the local newspaper delivered to residents' mailboxes starting in 1983. Her publication preserved the history of the area. Nash was a charter member of the historical society. (TOQC.)

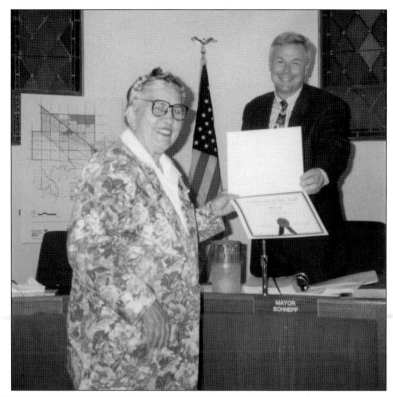

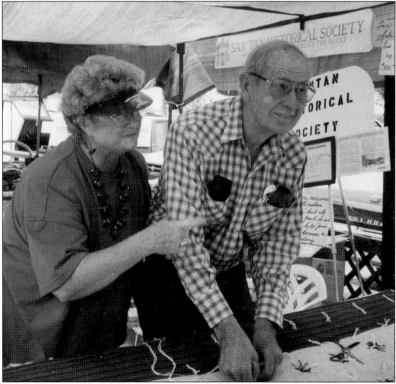

Gloria Greer and Ivan Cluff demonstrate the correct way to tie a quilt at the Schnepf Farms Potato Fest. Selling quilts was just one of the ways in which charter members of the historical society raised funds to restore the Rittenhouse School. Cluff was a Queen Creek pioneer farmer and a past president of the farm bureau. (Gloria Greer.)

BIBLIOGRAPHY

Hughes, Paul. *Boy Howdy!* Phoenix: STS Publishers, 1976.

Pickett, Frances Brandon. *Histories and Precious Memories of Queen Creek, Chandler Heights, Higley and Combs Areas, 1916–1960.* Queen Creek, AZ: San Tan Historical Society, 1996.

Salge, David. Images of America: *Around San Tan Mountain.* Charleston, South Carolina: Arcadia Publishing, 2007.

Sossaman, Sue. *Higley, Arizona: A Rural Community.* Queen Creek, AZ: San Tan Historical Society, 1999.

——————. *Queen Creek: A History.* Queen Creek, AZ: San Tan Historical Society, 1996.

Theobald, John and Lillian. *Arizona Territory Post Offices and Postmasters.* Phoenix: Arizona Historical Foundation, 1961.

About the San Tan Historical Society

The San Tan Historical Society is our community's first choice for history, serving the Queen Creek, Chandler Heights, Higley, and Combs areas with visions and values in preservation, restoration, education, and collaboration.

It began with a meeting in school superintendent Ralph Pomeroy's office in 1988 to share ideas about saving the historical schoolhouse. With an initiative of volunteers led by Betty Binner Nash and Mary Bendyna, a tea party was held at the community center on February 14, 1989, in the 77th anniversary year of Arizona becoming the 48th state. The support was tremendous, encouraging an effort by the community to restore the school in partnership with the State Historic Preservation Office.

Thanks to the efforts of San Tan Historical Society members and volunteers, the school was placed in the Arizona Historical Register in 1990. It is one of the last historical landmarks in the Queen Creek area.

From this enthusiasm, the San Tan Historical Society was established in 1990, and has been recognized as a nonprofit 501(c)(3) organization in good standing since September 1992. Successful partnerships in the community have helped to promote our visions and values through the years, and our family of volunteers has ensured our continued success with clear objectives, sound decisions, and initiatives established on cooperation.

Our museum is at the Rittenhouse Elementary School building in Queen Creek, which was listed in the National Register of Historic Places in 1998. The society is located at 20425 South Old Ellsworth Road, Queen Creek, Arizona 85142. The website is www.santanhistoricalsociety.org, and the phone number is (480) 987-9380. It is open to the public, free of charge, on Saturdays from 9:00 a.m. to 1:00 p.m.

Discover Thousands of Local History Books Featuring Millions of Vintage Images

Arcadia Publishing, the leading local history publisher in the United States, is committed to making history accessible and meaningful through publishing books that celebrate and preserve the heritage of America's people and places.

Find more books like this at
www.arcadiapublishing.com

Search for your hometown history, your old stomping grounds, and even your favorite sports team.